Yarmouth

MURDERS & MISDEMEANOURS

Yarmouth
MURDERS & MISDEMEANOURS

Frank Meeres

AMBERLEY

First published 2010

Amberley Publishing Plc
Cirencester Road, Chalford,
Stroud, Gloucestershire, GL6 8PE

www.amberley-books.com

British Library Cataloguing in Publication Data.
A catalogue record for this book is available from the British Library.

ISBN 978 1 84868 459 1

Typesetting and Origination by Amberley Publishing.
Printed in Great Britain.

Contents

Introduction

Today, Great Yarmouth is known mainly as a holiday resort, but through most of its history it has also been an important port, one of the largest in England in the Middle Ages. This has given the town an international flavour, as sailors from ships based in ports all over the world met together in its bars and markets. It also had a unique shape to it — the Rows. These made up a gridiron of extremely narrow, parallel streets, where thousands of people lived in cramped conditions, in houses that rarely saw direct sunlight, and special carts had to be used to take goods into them. Many of the crimes described in this book took place in these Rows, which survived into the twentieth century; German Air Raids and borough planners have since seen the end of almost all of them. The most important part of the town was the quay, where ships loaded and unloaded. There were no buildings outside the town walls: beyond them lay the Denes, an enormous sandy area facing the sea.

Yarmouth is a free borough and has been since 1208. This has affected the way in which crimes have been dealt with over the centuries. The borough court dealt with quite serious crimes and had the power to inflict capital punishments in the Middle Ages. Gradually, three levels of court developed. The lowest was the police court or petty sessions, where one or two magistrates handed out fines or prison sentences of up to six months for minor offences. These do figure in this book, because the magistrates also met to look at major crimes like murder, and if they decided there was a case to answer, they committed the prisoner for trial before a jury at the county assizes. The petty trials and first hearings took place in the town hall, either the present one, which was built in the later nineteenth century, or in its predecessor on the same site. If a person was committed for trial at the assizes, he or she was transferred to Norwich prison. The trial was held in Norwich, and if execution followed, this took place in Norwich rather than Yarmouth. Executions were in public until 1868, after which they were held in

private inside the prison. The courts and prisons in Norwich are described in my *Norwich Murders and Misdemeanours.*

Between the petty sessions and the assizes, came an intervening court, the Quarter Sessions. The magistrates met in the town hall every three months and dealt with crimes, mainly thieving of various kinds. There was a jury and, if convicted, punishment in the late eighteenth century and nineteenth century was very often transportation to Australia. The court jealously guarded its rights: it could try murder cases and it could impose a sentence of death.

In these cases, of which there were not very many as we shall see, the execution took place in Yarmouth itself. The traditional place of execution was on the border between Yarmouth and Caister at the White Gate, but other places were also probably used in earlier times. The last execution in Great Yarmouth was that of John Hannah, described below — and, as we shall see, was not at the White Gate. The Quarter Sessions lost the right to execute people in 1835 and all murder trials after that were held in the assize courts and not in Yarmouth.

There was another court in Yarmouth that could sentence people to death: the Admiralty Court. Amongst other things, it dealt with cases of piracy, and some of these cases are discussed below.

There has only ever been one prison in Yarmouth, and this was in the cellars of the Tolhouse, one of the oldest civic buildings in Britain. This is now a museum and is well worth a visit if you are interested in the themes of this book.

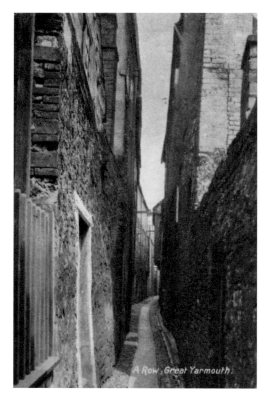

Left: *A typical Great Yarmouth Row*

Below: *Yarmouth cart on the beach*

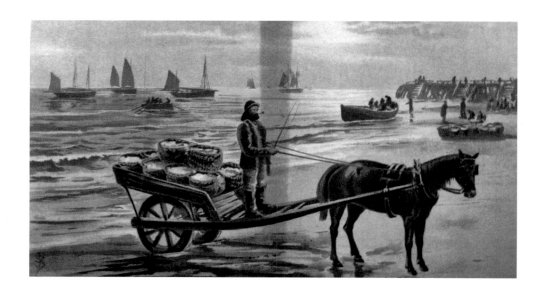

CHAPTER 1

The Middle Ages

In medieval Yarmouth almost everybody carried a knife, and knife crime was far more common than it is in the twenty-first century, despite the impression sometimes conveyed in today's newspapers. In the period 1366-1381, for example, there were about six murders a year on average in Yarmouth, and 238 other violent crimes where blood was spilt. Of these ninety cases, about six a year involved knives, most of the others with sticks or fists. Twenty-one of these cases involved the use of swords — a weapon not often found today — and four involved the use of spades! Quite often the murder victims were unidentified strangers, like the Dutchman from Amsterdam beaten to death by a local man, and these incidents no doubt came out of arguments among sailors and fishermen, fuelled by consumption of alcohol in the many taverns of the busy port.

In such a place, there were inevitably many prostitutes. These were normally fined on the first offence and put in the pillory on their second. If they committed a third offence they were banished to live on the Denes, the sands outside the town walls; they could only come into town if they were wearing a uniform in the shape of a striped hood! They were not the only 'hoodies' involved in criminal activity in medieval Great Yarmouth. Seven hundred years ago, in 1312 to be exact, Sybil Climne was walking along Middlegate (today called Howard Street) when a man grabbed her by the hood and dragged her into one of the Rows; he used the hood in an attempt to strangle her. She, too, was carrying a knife, and she managed to stab the man in the stomach, and he fell to the ground and died. At the trial, the man was found to be called Godfrey de Watles, and, according to the jurors, he was a lunatic in the most literal sense of the word: mad 'in the crescent of the moon'. As it was clearly self-defence, Sybil was acquitted of murder.

The Denes covered a very large area and were the place where everything unwanted within the town wound up: lepers were sent there and the town's

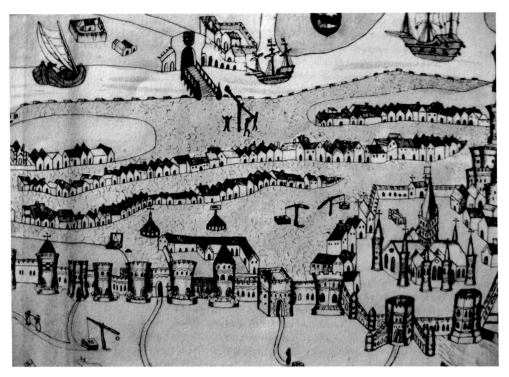

The Market Place, from a map of the 1580s

rubbish was also dumped on the Denes! There was some provision for lepers in the form of one, possibly two, small hospitals. Although leprosy was feared as a contagious disease, this did not prevent a gang of men breaking into one of the leper hospitals, killing a man named Ralph who worked there and helping themselves to hospital funds.

Forgers of coins also worked in fourteenth-century Yarmouth, such as Margaret Topcroft who made fake groats (a coin worth 4p) out of base metals. These coins had the head of the king on one side, which meant that the crime of forgery was treated as treason — the punishment was hanging, drawing and quartering for men, burning at the stake for women. Margaret was fortunate. Perhaps it was her natural charm that got her out of trouble — the Tolhouse gaoler not only helped her escape but let her steal money from the Tolhouse coffers on her way out!

CHAPTER 2

The Great Yarmouth Witch Trials

One aspect of popular religion was the belief in witchcraft. Occasional accusations of witchcraft occur throughout the ages, but in Yarmouth, as in most towns, they were at their peak in the sixteenth and seventeenth centuries, culminating in the Great Witch Trial of 1645.

A typical earlier case is that of Elizabeth Butcher. In March 1582, Elizabeth and another woman, Cecilia Atkin, were found guilty of witchcraft by the Yarmouth Sessions Court. They were sentenced to stand in the pillory in the market place every market day until they confessed their guilt. Cecilia presumably did so, as she disappears from the record, but Elizabeth was more obstinate; in August 1582, Elizabeth was sentenced to a year in gaol, unless she confessed her guilt, and to make occasional appearances in the pillory 'as an example to others'. Even this was not the end, and in April 1584 she appeared again before the judges; this time she was sentenced death by hanging, along with another woman found guilty of witchcraft, Joan Lingwood. There were occasional cases in the years that followed, such as that of Helen Gill who was accused of practising witchcraft in the town against a certain Catherine Smythe in 1587.

However, the biggest trial was that of 1645. Yarmouth Assembly actually invited Matthew Hopkins (the well-known 'Witchfinder–General') to come to the town to 'discover and find out' witches. He later claimed to have had sixteen witches hung in the town, but this seems an exaggeration. On 10 September 1645, eleven people appeared before the sessions court charged with witchcraft of various forms. Two of them were men.

First before the court was Marcus Prynne, a gardener. He was accused of bewitching a man called John Howlett as a result of which Howlett sickened and wasted away. He was also accused on two further counts, which appear to be clairvoyance rather than witchcraft as such. He told Ann Cant where a cushion was that she had lost and told John Ringer where to find some silver

coins he had mislaid. The jury found Prynne 'not guilty'. He was followed by two women, Barbara Wilkinson and Elizabeth Fassett, both accused of 'feeding and entertaining evil spirits', but they too were found 'not guilty'.

The fourth person to appear, Maria Vevey, or Verey, faced more specific charges as well as the usual 'entertaining and feeding evil spirits'. She was accused of practising witchcraft on four named people: Bridget Wade, wife of John Wade, hosier; Elizabeth Holmes, infant daughter of John Holmes, sailor — 'who for five months sickened, consumed and languished'; Lucy Lambert, infant daughter of James Lambert and Augustine Thrower, merchant — 'for six weeks such child lingered'. However, Maria was acquitted on all counts.

The fifth accused was a sailor called John Sparke. He was also acquitted. There had now been five trials and five acquittals, but the luck of the defendants was about to change. Next up was Alice Ceipwell, charged with 'having used practiced and exercised witchcraft, and with many evil, wicked and diabolical spirits then and there consulted and made compact and the same evil spirits with evil intention did feed and entertain'. Alice was found guilty and the judges

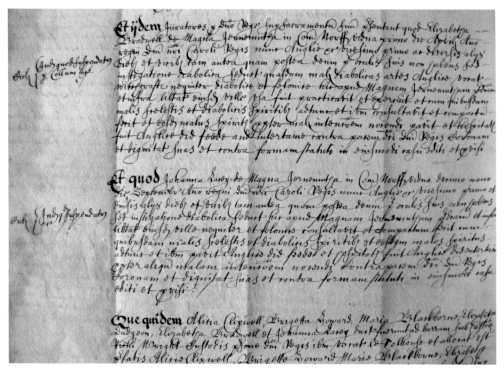

Judgement of death on two Yarmouth 'witches', 1645

sentenced her to hang. She was followed by three more women, each accused of 'practising witchcraft and feeding and entertaining evil spirits'. These were Brigetta Howard and Elizabeth Dudgeon, spinsters, and Maria Blackborne, widow. Each was found guilty and each was sentenced to death by hanging.

The tenth prisoner was Elizabeth Bradwell. She was accused not only of sorcery and witchcraft, but also of the specific offence that she had 'diabolically and feloniously used, practised and exercised upon and against John Moulton, the infant son of Henry Moulton, hosier, from which the said child in the greatest peril suffered and languished'. She too was found guilty and sentenced to death by hanging. The final prisoner, Johanna Lacey, widow, was charged with similar offences and also found guilty and sentenced to death.

For some reason, the sentence on Johanna Lacey was respited (postponed), but the other five women were hanged together. This dramatic event presumably took place at the gallows on the boundary between Yarmouth and Caister, no doubt watched by an enormous crowd.

After this trial, the jurors of Yarmouth seem to have been satisfied. Five further people were charged with witchcraft at the sessions court of the following April: John Smyth; Dioni Kirsp, alias Avery; Dorothy Dewe; Ann Parke; and Elizabeth Clark. All were acquitted. There were no witchcraft cases in September 1646 and only one in April 1647. This was Maria Verey, one of those acquitted at the great trial of eighteen months earlier, but she was again found 'not guilty'. In this year, Matthew Hopkins is himself said to have suffered the fate he had inflicted on so many others, being publicly hanged as a sorcerer.

One family, who may well have been in Yarmouth at the time of the Witchcraft Trials there, were to feature in the most famous of all witchcraft trials, those at Salem in Massachusetts. William Towne, who was living in Yarmouth in the 1640s, emigrated to New England with his wife and two daughters, Rebecca and Mary. They settled at Salem where they had another daughter and a son. Rebecca married Francis Nurse and Mary married Goodman Easty. In 1692, Rebecca, now over seventy years old, and Mary were two of the women sentenced to be hanged in the infamous Salem Witchcraft trials. The third daughter, born in America, had also married. Sarah Closse, as the third daughter was now known, was also put into prison but appears to have escaped execution.

Fear of sorcery continued until well into the nineteenth century. In 1834, a man living in Lowestoft wrote of the mayor of Yarmouth complaining that a woman living in one of the rows near St George's church was bewitching him. He complained he could get no rest 'day or night, sitting, standing or walking' and that 'even at church he could get no comfort'. He wanted the mayor to examine the woman but there is no evidence that he ever did so.

CHAPTER 3

North Sea Pirates

Many people have heard of the *Pirates of the Caribbean* and light-opera lovers know of the *Pirates of Penzance,* but few know about the pirates of the North Sea. There were plenty of these however, and if you want proof, all you have to do is go into Yarmouth churchyard and read the story of Daniel Bartleman on his tombstone:

> To the memory of DAVID BARTLEMAN, Master of the brig *Alexander and Margaret* of North Shields, who on the 31st of January 1781 on the Norfolk coast with only three 8-pounders and ten men and boys nobly defended himself against a cutter carrying eighteen 4-pounders and upwards of a hundred men commanded by the notorious English pirate FALL and fairly beat him off. Two hours after the enemy came down upon him again. When totally disabled, his mate Daniel Macauley expiring with the loss of blood, and himself dangerously wounded, he was obliged to strike and ransome. He brought his shattered vessel into Yarmouth with more than the honours of a conqueror and died here of his wounds on the 14th February following, in the 25th year of his age. To commemorate the gallantry of his son, the bravery of his faithful mate and at the same time mark the infamy of a savage pirate, his afflicted father, Alexander Bartleman has ordered this stone to be erected over his honourable grave.

Yarmouth was given the right to try pirates under the charter of James I (1608). The first piracy trial was held on 25 March 1613. Five men who had landed at Yarmouth on a ship called the *Seahorse* were accused of capturing her and her cargo at sea. The cargo consisted of 22,000 lampreys, 30 barrels of beer and 6 barrels of red herrings. Lampreys are a kind of fish, so this was not the kind of 'treasure' that would have excited Long John Silver — or Johnny Depp and Keira Knightley! Nevertheless, it was a considerable, and valuable, haul, and one that

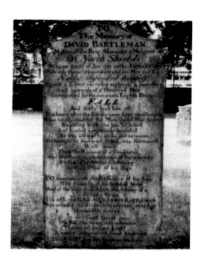

Grave of Daniel Bartleman in Yarmouth churchyard

cost some of the pirates their lives. Three of the men — Thomas Jinkins, Michael Muggs and Edward Charter — were hanged.

There was another piracy case in the town just two years later, tried in the Tolhouse before the court of Quarter Sessions. The accused were three men from Dunkirk: John Derickson, John Cisseran and John Bassee. They were three of a gang of pirates who had captured two ships, the *Lyon* and the *White Hound*, both from Danzig, wounding or capturing the crew, who on the *Lyon* at least were not foreigners but men from Newcastle. Again, profits were not great — six barrels of beer, three barrels of biscuits and some cash from the *Lyon* for example — but all three men were sentenced to death. The sentences on Cisseran and Bassee were respited, but John Derickson, presumably the 'pirate chief', was publicly hanged for his crimes.

There were several other piracy trials in the first half of the seventeenth century, and, after a lapse of nearly 200 years, a final case was heard in September 1823. This concerned the theft of a trunk from a ship lying at anchor in the Roads; the trunk contained the ship's papers, about £26 in cash, and other articles. The two 'pirates' were Edward Morgan and Thomas Rud Bebb, alias Hunt. Morgan was sentenced to seven years' transportation, and Bebb was gaoled for six months. The Yarmouth Admiralty Court, which held the piracy trials, was abolished in 1835.

They were not the only pirates to be associated with Great Yarmouth. William Paine, an infamous pirate who terrorised shipping off Eastern England, was tried and executed in London in 1781. His body was brought to Yarmouth by wagon, supposedly in a wooden box marked 'GLASS. WITH CARE' (this phrase was

Sailors on the Southtown Road, 1742

Modern day 'pirates' on the Marine Parade

later used on the boxes containing the bodies stolen by resurrectionists. In both cases, local wits are supposed to have scrubbed out the 'G' of the label!). The body was hung in chains on a 48-feet high gibbet on the North Denes where it remained until 1804, and it is shown on William Faden's map of 1797. The site was thereafter known as Paine's Hill.

Another pirate with Yarmouth connections was John Clipperton, who was born in the town. In 1715, he was chief mate to the famous pirate William Dampier on the *Saint George*. They were active in the Caribbean, attempting to raid Santa Maria in the Bay of Panama. When the attack failed, Clipperton led twenty-one of the crew in a mutiny: they sailed off in one of Dampier's ships on an immensely successful — and profitable — raiding voyage. However, when he tried to repeat the success in 1718, his own crew rebelled against him! He was able to return home, and, unlike many pirates, he died in his bed.

CHAPTER 4

Two Eighteenth-Century Murders

In 1735, a murder was committed at the Tuns Inn in Row 108. A group of Dutchmen were drinking in this inn, and when the group left, one of them remained for more drinks. He was never seen alive again. Later, his body was found in the river, showing marks of violence and with the ears cut off (presumably for the gold earrings that Dutchmen wore). The landlady, Elizabeth Thompson, and nine other women were arrested. Thompson was tried and found guilty of being an accessory to murder. She was sentenced to death but was offered a free pardon if she would name the actual murderer. She refused to do so and was hanged. Many years later, a man is supposed to have confessed to the murder on his deathbed.

Elizabeth Martin was a domestic servant living in the large Georgian house known as 20 The Quay. In 1769, she was accused of the murder of her illegitimate child, found guilty and hung; she is the last woman to have been hanged in Yarmouth.

CHAPTER 5

John Boult Hannah, the Last Hanging in Yarmouth

Hannah and his wife Elizabeth lived at their house in Mew's half row, or Row 91. In 1813, she was in her late sixties and he was over seventy years old. On 15 April, death came suddenly to Mew's Row: Elizabeth Hannah was found murdered. The case is a fascinating one because of the detailed records that survive among the Yarmouth Borough Sessions in the Norfolk Record Office. These are the original statements made by the witnesses and by Hannah himself on the actual day of the murder. They are in a curious mixture of first-person statements and third-person reportage, and were made by the coroner Robert Cory or one of his clerks. Each statement is 'signed' by the witness: many could not read or write so they have simply put their marks to the papers.

Elizabeth Hannah's body was found on the morning of 15 April, and the inquest was held that same afternoon. Cory called together a jury of twelve men at the house of Mr Wicks. They viewed the body of Elizabeth, and we can imagine the process as the jurors listened to the statements of the witnesses.

Ann Betts, the wife of John Betts, a Yarmouth labourer, was first to take the oath and give evidence. Her statement reads:

She lives in a chamber over the room in a Dwelling-house situate in this Borough occupied by the said John Hannah, and that this morning about three o'clock being in bed and asleep this Informant was awoke by hearing the said Elizabeth the wife of the said John Hannah call out, 'Mrs Betts come down, I am murdered', and that she repeated it again when the informant got on her shift and came down stairs to the door at the entrance of the room of the said John Hannah, and that the said Elizabeth Hannah still kept calling out for the Informant to go to her which the informant stated that she dare not do and requested the said Elizabeth Hannah to come out of her room; that the said Elizabeth Hannah not doing so, the Informant went up to the Watch-house to call for assistance, but not finding any, she returned

to the stairs leading up to the room, when she again heard the said Elizabeth Hannah calling to the said informant to come and assist her for that she was murdered, that she kept calling she was murdered for near a quarter of an hour when the Informant heard her give three heavy groans and the noise ceased.

That the Informant several times called at John Hannah, 'You wicked old man are you going to kill your wife?', and addressed other language to him but received no answer and she never heard anything of him. That after the noise ceased the Informant went to bed, believing that the noise and cries had arisen from a quarrel between the said John Hannah and Elizabeth his wife, having been constantly in the habit of having these quarrels' She had heard the poor woman call out 'Murder' several times during the four years that she had lived above them.

Her statement continued:

That she the Informant again got up at about half past six o'clock from which time she listened for one person in the room but could not hear any person move till between nine and ten o'clock this forenoon when she got a chair and looked into the window of the room of the said John Hannah and saw the said Elizabeth Hannah lying on the bed apparently dead but never saw the said John Hannah. That about ten o'clock the door was broken and the room entered by several persons, who soon after came out of the said room and with them she saw John Hannah, who she addressed saying, 'You wicked man, what have you done?', to which he answered, 'This may all be thank you' [presumably meaning 'this may be all thanks to you']. That from the time she last arose she did not see the [said] John Hannah enter his said room, and she believes he was there at that time.

Ann Betts could not write, so she put her mark to this statement.

The second witness at the inquest was Ann Thompson, spinster. She said that she lived near the east end of the row in which John Hannah had a room. This morning, about half past three, Ann Betts had come and called the witness up and said that she thought that John Hannah was killing his wife. Ann then put her head out of the upstairs window, and heard Elizabeth call out several times, 'Murder'. She stayed at the window for a quarter an hour while the cries continued — and then she went to bed. She too made her mark to her statement.

The third witness was Godfrey Goddard, ironmonger.

At about ten o'clock he went to his workshop at the west end of Mew's half row, and was told by his workman that a woman in the Row had been murdered. He went into the Row and saw several people outside the house occupied by Hannah: Ann Betts was among them. She told Goddard that Hannah had killed his wife,

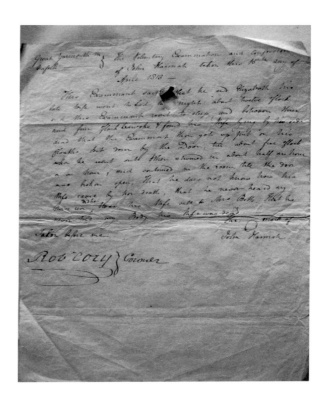

John Hannah's statement made just a few hours after the murder of his wife

and that several people had looked into the window and seen her lying on her bed stretched out. Goddard asked why the door had not been broken open and was told by a Mr Fulcher, a constable, that he dared not break the door open without an order. Goddard went and found another constable, James Storey, and they forced the door open with an iron frow (an old word for a wedge-shaped tool). They did not call out for anyone inside to open the door as they assumed the house was empty. Goddard did not go in himself, but saw Storey, William Grave the younger and several others enter, and heard one of them call out that Hannah was there and that his wife was dead. He saw Hannah come out and he was afterwards carried to the gaol.

Goddard signed this statement.

James Storey was a fish curer as well as a part-time constable (there was as yet no professional police force). He told his story to the jurors:

Goddard had called on him about eleven this morning, and said, 'Good God Storey come up of the Row for old John Hannah has killed his wife'. They went together and saw several people outside Hannah's house. Storey looked in the window of

the room, but could see nobody so he got Goddard and his men to break it open with the frow. Storey went into the room with Fulcher, Grave and others. Hannah was sitting on a chair between the door and the bed with his face towards the bed. Storey went to the bed and saw part of a hand above the bed clothes, which had been perfectly smoothed over. The people with him turned down the clothes and saw the body of Elizabeth: she was dead. She was on her back with her arms by her side, having apparently been laid out. She was clothed but her neck was bare and Storey saw that her throat was very much bruised and her face looked very black as if she had been strangled. Storey said to Hannah, 'John, what have you done, you have killed your wife'. Hannah replied that she was always quarrelling with him. Storey told him there were 'other ways to have gotten rid of her' Hannah did not reply but went to his bureau and took out something and put it in his pocket. Storey arrested Hannah and took him to the prison. Storey added that Hannah was fully dressed in his best clothes.

Goddard signed the statement.

Then came Thomas Taylor, a baker. He gave evidence as follows:

… at about 10.30 that morning, he had heard that Elizabeth had been killed. He went to the house and looked in the window: he saw someone on the bed, covered up and apparently dead. When the door was broken open, he went into the room with the others. Hannah was sitting on the chair and Taylor asked him if his wife was ill or dead: Hannah answered that he did not know. He made the same comments about the body as Storey had, adding that there were also many bruises on her right arm. As Hannah was being led out of the house, Ann Betts said to him, 'John Hannah you old witch, how could you do so?' Hannah replied in the exact words already quoted, 'it may all bethank you', adding a significant extra sentence — 'it was about your rent'. Taylor said he did not think Ann Betts heard Hannah say this; if she had, she conveniently did not mention it in her evidence under oath!

Taylor signed his statement.

Finally came the medical evidence, given by two Yarmouth surgeons, William Taylor and Charles Costerton. They both sign the statement and their evidence is given as one, so presumably they were in agreement as to the facts. They went to Hannah's house at about 1 p.m. They saw the body of a woman lying dead. They too noticed the bruises on the right arm, but had no doubt from looking at the marks on her neck that she had been strangled with a cord or rope, and that this had led to her death. From the appearance of the body, they thought she had been dead about seven or eight hours. If they were correct, she must have died between five and six in the morning.

The Tolhouse, exterior view

Coroner Robert Cory was not finished. He spoke to John Hannah himself and obtained an immediate statement, which also survives. Hannah said the following:

> … that he and his wife went to bed about twelve o'clock the previous night. Between three and four o'clock in the morning he awoke and found his wife lying by his side: she was dead. He got up, put on his clothes and sat down by the door until about five o'clock, when he went out for about half an hour. He came back and sat in the room until the door was broken open. He did not know how his wife came by her death, he had never heard any noise and did not hear his wife call to Mrs Betts. He never told anybody that his wife was dead.

Hannah could not read or write, but he added his mark to the document in the form of a rough circle.

On the same day, Cory summoned the witnesses to appear at the next Quarter Sessions to give evidence on a bill of indictment against John Hannah. These were the medical experts, again always men, and witnesses, who could be women or men. In this case, the witnesses were the surgeons Taylor and Costerton, and seven other people. The occupations are given in the bond, making it a useful record for family historians. The seven are: John Larter, house carpenter; Robert Utting, upholsterer; Godfrey Goddard, ironmonger; Richard Rudd, painter; William Grave the younger, sail maker; James Storey, fish-curer Thomas Jay the

younger, baker. Their 'addresses' are given, but this is just the parish in which they were living, not a street and house number, as we would expect today. The 'address' of all nine people is given simply as 'Yarmouth'.

These documents, all written on the actual day of the murder, give a sense of drama to what is really a sad but not unusual case. The next stages in the proceedings were inevitable. Hannah was held in the Tolhouse prison until he faced trial at the next sessions court, which was held in the town hall (the predecessor of the present building) on 27 April, less than three weeks after the murder. Perhaps surprisingly, Hannah pleaded 'not guilty', but in view of the overwhelming evidence he was found 'guilty' by the jury and was sentenced to death.

Hannah was publicly executed on 6 September 1813. This was the first execution to be held in the town for sixty-four years. The great and the good of the town marched with Hannah in their full regalia from the Tolhouse to the place of execution. A new 'drop' had been erected for the occasion on the sea front, between the Telegraph and North Star batteries. More than 10,000 people watched this old man meet his death. A further punishment awaited him: the dissection of his body by surgeons.

The words of Hannah to Ann Betts might imply that he rented the house from her, but in fact it was the other way around: he was the house owner and Ann the tenant. As a convicted felon, all his property passed to the Corporation — the house and its contents, including his watches, earrings and buckles. The Corporation later sold the house for £10!

The drama of a public hanging had been played out for centuries in Great Yarmouth, but this was to be the last time. It had become rare for Quarter Sessions courts to condemn people to death: the Yarmouth Sessions did so just once more in 1825, and then no one was actually executed, as we shall see. John Hannah had led a very ordinary life, and he was never do know that the drama of his death was to be the last of its kind in his home town.

Hanging followed by dissection may seem savage treatment for an elderly man, but these were times of great violence, both by criminals and by the state. In the same year as Boult was hanged and his body dissected, a girl in Zeeland who had poisoned her father was sentenced to be conveyed from her family home to the place of execution, to be tortured five times on the way with red hot pincers, to have both her hands struck off — and only then to be beheaded. Nearer home, in Norfolk, savage treatment was rendered to a woman called Mary Turrell, who was suspected of having murdered a child in Harleston, and had committed suicide. As there had been no trial, she was an innocent woman, but suicide itself was a crime to be punished, and she was buried in the high road and a stake driven through her body in the presence of a great crowd. In Norwich, two men

were hung in public on Castle Hill, not for murder but for a single robbery. After they were dead, the bodies were just cut down and handed over to the grieving families to deal with. These events all took place in 1813, and were considered normal. Attitudes to crime and punishment have changed immensely over two centuries, which is part of the perennial fascination of the subject.

There were other forms of punishment in nineteenth-century Yarmouth too, which have long since fallen out of use. On Wednesday 19 August 1812 — market day — William Flaxman was placed in the pillory in the Market Place, and then returned to prison to complete his three-month sentence for perjury. On Saturday 23 February 1828, a man called Bailey did penance in Saint Nicholas' church for verbally abusing a Miss Jeanor: 'it being a great novelty here, there was a large assemblage of persons to witness the performance of the ceremony, and to hear Bailey repeat his incantations, which he continued for some time, but he did not, as generally supposed, stand in a white sheet'.

CHAPTER 6

Poison in the Rows

The Neal or Neale family lived in Row 133. In 1825, Mary Neal, who was forty-two, with her children Susan (twenty-one) and William (eighteen) were accused of trying to murder a shoemaker (the old word is cordwainer) named William Hales and his family. Once again, we can trace the progression of events through the records made at the time, now at the Norfolk Record Office. The first documents are the statements by Ann and William Hales, and by their doctor.

The drama began when Ann Hales, the wife of William Hales made a complaint before the mayor, William Barth, on 15 March 1825. She said that on the previous Tuesday she had boiled a piece of salted beef, some potatoes and dumplings in an iron boiler. After it was boiled, she left the liquid in the boiler, which she put in the kitchen, which was also used as a workshop by her husband and his apprentice William Neal. At dinner on Tuesday, the whole family ate part of the meal and the liquid at dinner, and she ate some at supper; none of them suffered any ill effects.

The boiler stood in the kitchen until dinnertime on Wednesday, when Elizabeth Fenn, 'a little girl who is a daily servant', brought it into the room where the family lived, and where Ann and her apprentice Maria Skoyles worked. The boiler was put on the fire. Ann took a cup of liquid out of it, drank most of it and gave the rest to her three-year-old son, William. The boy was immediately taken very ill and vomited very much, and while Ann was holding him she herself was taken sick. She managed to prepare thickening for the broth, to make some dumplings, and peel potatoes and turnips, putting the turnips in with some bones, all the while looking after Mary, her ten-month-old baby. As she was too ill to carry on, she gave the child to Maria and went to bed, leaving the thickening dumpling and potatoes to be put in by Elizabeth Fenn. While in bed, she became worse and could not get up to dinner. William junior also got worse and was put into bed with her.

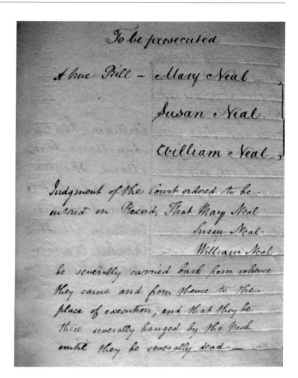

The last death sentence passed in Yarmouth: the Neal case

Her husband William also made a statement. He said that he came into the room for his dinner a little after 1 p.m. Maria told him that Ann had been taken ill, and he went up to her and asked her to come down to dinner. She said that she was too sick, and that William junior was also ill. He went downstairs, Fenn took the dumplings, potatoes and turnips and William took up the broth and bones. William ate one dumpling, with some gravy, which had been left from some pork on the Sunday, together with some of the turnips and a small quantity of the broth. He also gave baby Mary some dumplings and some of the same gravy. His other daughter, Ann, had some dumpling and broth, and Fenn had a dumpling and two or three spoonfuls of broth, and she also fed some of this to Mary. The effects were immediate: Mary was at once taken very sick, followed by Ann junior. William took Ann upstairs and laid her down in a bed in his wife's room. When he came down, Fenn had taken Mary into the yard, where both of them were vomiting.

Hales naturally thought at once that there must be something in the food. Despite beginning to feel 'qualmish' himself, he went to Charles Costerton the surgeon. He found Costerton's assistant, Robert Hook, who said Costerton was out 'in the south end' of town. Hook went up Chapel Street to find him, while Hales went along the quay, up Friars' Lane, but he could not find Costerton,

and he came home alone. However, in a few minutes, another surgeon, Mr Borrett, came to the house with Hook. Borrett ordered some medicine, which the assistant fetched. They were just about to take it when Costerton himself turned up. Under his orders they took the medicine, which made each member of the family vomit.

Hales said that William Neal was out when the family had dined and when he came back from the surgeons, Hales saw him at work. Neal had been occupying himself by doing some writing, and Hales gave him a little work to do, saying that he could not give any more as everyone was so sick in the house. Clearly, Neal was not suspected of criminal activity at this stage.

On the same day, Costerton gave evidence before Robert Cory, as a Justice of the Peace. When he came home at about 3 p.m. on the Wednesday, he said, he was told that he must go to the Hales' house in Howard Street. There he found the whole family and the apprentice Maria Skoyles all sick upstairs. He gave them all an emetic and learned from William and Ann that the whole family had become violently ill after eating, with nausea, retching, followed by pain of the head, dizziness, coldness, trembling and perspiration. He visited them again at 6 p.m. when they were still very sick, and told them to drink freely of thin gruel with sugar in it. He came back at ten at night and ordered them to continue the medicine as before. He visited three times the next day, and again the next morning when at last he found them better: Maria had been well enough the previous night to go to her own home.

Costerton had also looked into the cause of the food poisoning. On his very first visit, he had asked whether any of the soup was left. Maria brought to him the boiler, which still contained about a pint of the soup, and he took it back to his house. He subjected it to various tests on the following day, and decided that it contained 'a considerable quantity of arsenic, which is a deadly poison'. He added that the family's symptoms were such as would arise from taking such a poison.

On the following day, the Neals were interviewed. We are extremely fortunate to have the notes made at the time by Cory (or his clerk) of these interrogations. Those interviewed were Mary Neal and her daughters Susan and Mary Ann. The questions were all about the purchase and possession of arsenic. Although the questions they were actually asked are not given, only their answers, we can see that they first deny any knowledge of the matter, but that, no doubt under relentless interrogation, they eventually break down and confess.

Mary Neal said that she had 'stuff' to put on bread and butter for mice three or four years ago. It was put in a closet for mice. Her husband was master of the *Lark*, and she thinks he bought arsenic for use on the ship. Mary said that she herself did not even know what arsenic was; she had never seen any, or indeed

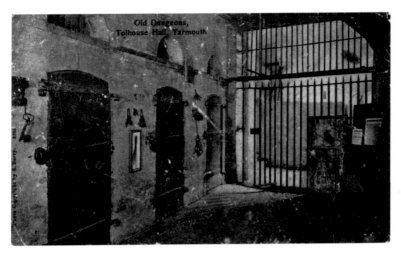

The prison cells in the cellars of the Tolhouse

any other poison. It was not possible that the arsenic that her husband had could now be in the house. She has never gone to any chemist to buy anything, but she has been at Mr Cary's to buy spices, alone. She does not go to a Chemist for medicine. Mr Taylor was her last surgeon. She knows Steward Chemists, Nash, Sancroft, Stacey. She knows Sothern lives in the street beyond the Ship Tavern, he is a chemist, but she has not bought anything of him or at his shop for the last month. Susan her youngest daughter goes 'a-shopping' with her.

Then, she changed her story, no doubt under pressure from Cory, admitting that she bought a penny worth of arsenic at Mr Sothern's on a Saturday evening. Her daughter Susan went with her. She bought it to destroy mice. She put it in a floret in the wash-house. She got her supper and when the boys were 'a-bed' she cut some little pieces of white bread herself and she put a very small quantity of arsenic on it and laid them on a shelf in the wash-house. Her two daughters, Mary Ann and Susan, were present. Her youngest daughter (Susan) took the rest of the poison and she has not since heard of it. At the time she bought the arsenic she was really troubled with mice in the house. She believed the arsenic was still in the house. She went to Nash's, asked for poison first. Mr Nash said she must have a witness. She was alone. At night she went to Sothern's with her daughter Susan, bought one penny (worth) of arsenic and gave it to her daughter Susan. The chemist asked her name, she said 'Neal', and that the young woman was her daughter.

Susan Neal was only twenty-one but lived away from home. She said that she had lived in a house in Mr Worship's Row for about two years. She had 'had rats

and mice in the house but not this year, has not had any since last Michaelmas, and had not bought anything to lay about to kill them. Her mother was in the shop of Mr Davy the chemist, but never bought anything home, and never dealt with any chemist but Mr Davy.' Eventually, she said that she and her mother had bought some arsenic at Mr Sothern's before Christmas, they did not use a half a quarter of it, and the rest had been destroyed. Questioned as to more recent Saturdays, she said that she did not go out at all on the previous Saturday; on the Saturday before that she went out between 7 and 8 p.m. with a young person of the name of Ingram. She did not go out again that night.

She thought that, when she went home one night, her mother had told her that her brother's master was ill, and her brother could not get any work, she 'could not go on so'. Her mother said they had been boiling broth in a boiler and turned sick. She had never enquired of her brother about it. Cory must have returned to the subject of arsenic and obtained a confession, as the notes conclude with Susan saying that her mother had bought arsenic from Sothern's shop, and that it was put in two papers written Arsenic Powder. She did receive the arsenic from her mother and put it on top of the clock.

Mary Ann Neal was older than Susan but still lived with her mother. She said that their present house was about thirty years old. She had never seen a beetle or a rat there, had heard mice but never seen them. A month or six weeks ago, five or six were caught with small wire traps belonging to her mother. She worked upstairs, coming down at meal times. There was a clock in the house, which she wound up every week, opening the face to do so, and she had never seen a paper on the clock. She had heard Susan say about three weeks ago that they had something to poison the mice but had never heard what hey had done with it. She had heard several stories about the Hales family, some saying that arsenic had been put into some copperas, adding that her brother was prentice to Mr Hales, but 'he did not do it'. Mary Ann was not thought to be party to the crime and was not put on trial.

On the next day, the chemist's assistant was interviewed. He was Philip Howlett of Samuel Sothern's shop. He was clear that it was on Saturday 26 February that two women had come in, the elder asking for arsenic. He fetched it and asked their names. He was told that her name was Neal and the young woman's was the same. He saw them again when they were before the mayor on 16 March and recognised them. They actually admitted before the mayor that they were indeed the women in question. Susan said that the remains of the arsenic were on the clock, and one of the sergeants at law fetched it. When it came back it was still in the wrappers in which Howlett had supplied it.

At the trial itself, William Neal tried to throw suspicion on Elizabeth Fenn, the servant girl, but the evidence against him and his family was too strong. Mary,

Susan and William Neal were all found guilty of mixing arsenic with soup to be taken by William Hales and his wife and their three children, and to Elizabeth Fenn, with intent to murder them. The court ordered judgement of death to be recorded against them, and this was done. However, nobody had actually died, and the Neals were not hung, but their death sentence was commuted to transportation to Australia. Never again did the Yarmouth Quarter Session pass a sentence of death.

CHAPTER 7

Body Snatchers in Great Yarmouth

Body snatching was the digging up of recently buried people from churchyards to sell to students in anatomy, whose only legal source of corpses was the bodies of hanged criminals such as John Hannah. The crime aroused great horror among ordinary people, who dreaded corpses of their loved ones being treated like this, but the courts treated it less seriously, usually giving a sentence of a few months in prison. A skilled 'resurrectionist', as a body snatcher was often called, could open a grave at night and take the body — and then replace everything so carefully that no one could tell that the grave had been disturbed. A body might fetch £10 or £12, a good sum of money 200 years ago, and one for which it was well worth risking a short prison sentence. The bodies had to be fresh and not decomposed, so the criminals would often hang around at funerals pretending to be mourners, marking down their future targets.

One of the leading London surgeons happy to buy bodies and ask no questions was Astley Cooper, himself a Yarmouth man, so it is fitting that one of the most well-known cases of body-snatching should have been in his home town. The villain was Thomas Vaughan, alias Smith, and the date 1827. He and his associates rented a room opposite the west end of St Nicholas' church, in Row 6, also known as Boulter's Row (and known afterwards as Snatchbody Row!). They dug bodies out of the churchyard, moved them into their house and then sent them to London by wagon. In Christmas week of 1827, rumours of bodies being snatched from Great Yarmouth churchyard reached a crescendo. The *Norfolk Chronicle* describes the scene:

> The sensation produced was universal: the churchyard was quickly crowded with the populace. Wives were seen searching for the remains of their deceased husbands; husbands for those of their wives: and parents for their children. Bodies to the number of twenty or more were found to have been removed: and the grief

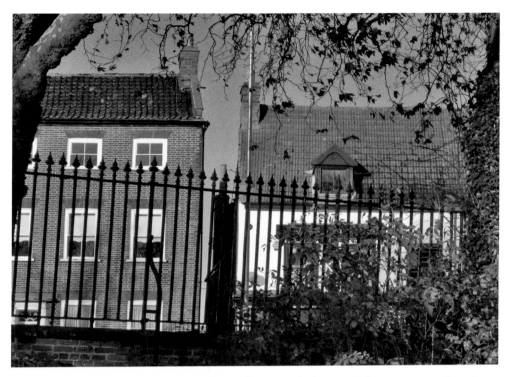

The railings around the churchyard. The gap between the houses is the entrance to Snatch Body Row

Great Yarmouth churchyard, scene of the body snatching case

of those who search was vain can be better imagined than described. Through the natural but over-strained anxiety of near relations the bodies of many which had been undisturbed by the resurrectionists, were on this occasion exposed to view; while everywhere the broken and plundered coffins were displayed to the eyes of an infuriated multitude.

In fact, ten bodies appear to have been taken out of the graveyard in October and November 1827, including Helena Brightman, buried with her unnamed infant son, and twenty-one-year-old Elizabeth Beck. The chief suspect, Thomas 'Smith', was taken in Southwark, and two supposed accomplices, William Barber and his son Robert, were apprehended in Beccles. On 7 January 1828, Vaughan was committed for trial by the Yarmouth magistrates, still under the name of Thomas Smith. He was granted bail and is supposed to have left Yarmouth disguised as a sailor to avoid the anger of the crowd. When he got to London, he was able to get his case transferred from the Borough Sessions to the Assize Courts. The case was heard in Norwich on 11 August 1828. Robert Barber agreed to speak against Vaughan and the case against both the Barbers was dropped.

Vaughan was charged with two bodysnatching offences, stealing the bodies of Elizabeth Beck and of a person unknown. George Beck, Elizabeth's husband, gave evidence that he had gone to the churchyard, opened the grave and found the coffin lid broken and the body gone. The dress she was wearing was still in the coffin.

Robert Barber said that the two men had climbed the churchyard wall. Barber had kept watch while Vaughan opened a grave, put the body in a sack, and carefully filled the grave up again. He repeated the process at another grave. They took the sacks back to the stable they had rented in Boulter's Row, put them into pre-ordered boxes 2 feet 3 inches in length, 14 inches wide and 14 inches deep. The boxes were marked 'GLASS. WITH CARE', and were sent to London.

Vaughan received six months, which he spent in Norwich Castle Prison. Astley Cooper and his surgeon friends were clearly on Vaughan's side. They sent down a legal expert to act on Vaughan's behalf, at a cost of £14, and they also gave Vaughan's family 10s a week while he was in gaol.

Vaughan was in fact a 'professional' body snatcher — that is, he practised the trade in other places besides Yarmouth, before and after his time in prison, and it was his chief way of making a living. He had previously been a stonemason's labourer, so had had experience of tombs and burials before embarking on his strange new career. He continued his profession after his release, and it was eventually to prove his undoing. Some years later, he was actually found in possession of clothes he had taken from a dead body he had dug up in Plymouth. This 'theft' raised his crime to the level of felony and he was transported to Australia.

After 1827, high fences were put up around Yarmouth churchyard to prevent a repetition of the crime, and these can still be seen along the western boundary of the churchyard.

CHAPTER 8

Women and Crime

Most petty criminals were men, but sometimes women were involved and usually they received prison sentences, a few being sentenced to transportation. Here we look at just a few examples from the nineteenth century. Two women came before the Yarmouth Quarter sessions on 1 April 1827. One was Elizabeth Chapman, forty-seven, who was charged with having stolen two pieces of ribbon and a pair of gloves from William Johnson. She was found guilty and sentenced to six months in the Bridewell, the last month to be in solitary confinement. The other was Hannah Battledore, aged thirty-six. She was alleged to have stolen a hat, a shawl, a pair of 'highlows' (a kind of boot that stretches up over the ankle), and a basket — all the property of Benjamin Spink. The jury found her guilty and, although there is no record of her having committed any previous offences, she was transported for seven years.

Three years later, Sarah Pye was found guilty of stealing a piece of cotton print. Sarah was sentenced to three months imprisonment in the Bridewell. In 1846, a mother and daughter were up before the court — Elizabeth Cunby, aged fifty-eight, and twenty-six-year-old Naomi Cunby. They were charged with stealing cloth from the shop of Mr Parker in Broad Row. Elizabeth had been looking at a piece of lilac print. As they left the shop, Parker accosted them. The print was lying close to the door — it was not wrapped. The two women claimed that they had been sold it by the young shop assistant, Charlotte Hubbard. Hubbard denied this, stating that they had visited the shop twice before buying a few small items, some bonnet ribbon and some fancy flowers for cap trimmings, and they had asked about the lilac print and looked at it, but had not purchased it. The jury found the women guilty. The Recorder said that, 'He should make a marked difference in the sentences of mother and daughter: the elder prisoner had evidently trained up her daughter in vice instead of virtue.' The sentence he gave was nine months' imprisonment for Elizabeth, three months' for Naomi.

The newspaper reporter had less sympathy for Naomi, commenting that 'she is unmarried and very near her confinement: she conducted herself during and after being sentenced with the most brazen-faced effrontery'. Also before the court in 1846 was twenty-year-old Sophia Bond. Accused of stealing a velvet hat and a shawl, she was sentenced to transportation to Australia, the last woman to be transported by the Yarmouth magistrates.

CHAPTER 9

'Born to be Hanged': Charlotte Yaxley

The Yaxley case is of interest for the light it sheds on the lives of the poor in Great Yarmouth at the very beginning of the reign of Queen Victoria. They lived huddled together around tiny yards with no water supply or sanitation. The men worked in the fish trade; the women, if they were lucky, got factory work, the less fortunate often being forced into prostitution. This was the world of Charlotte Yaxley.

On 28 August 1840, according to the Yarmouth parish register, John Yaxley, a fish-seller, married Charlotte Middleton, a weaver, at Saint Nicholas' church in Yarmouth. She was presumably brought up a country girl, as her father is described as a farmer. Both John and Charlotte were living at Market Gates (now the name of Yarmouth's main shopping centre), and both were illiterate — they made their marks in the parish register. One of the witnesses was Sarah Ann Yaxley, who was also illiterate, and she will turn up again later in the story.

Seven months later, at the end of March 1841, a broadside appeared on the streets of Yarmouth:

A true and correct account of a most Barbarous and inhuman MURDER committed in the town of Great Yarmouth on Tuesday the 23rd of March 1841. The town of Yarmouth and its suburbs was thrown into a state of great excitement on Tuesday afternoon, on account of a most Horrid Murder, committed on the body of Mary Ann Karrington by Charlotte Yaxley, who was an illegitimate daughter, of John Yaxley, her husband; and on account of a dispute arising between the Mother and Father of the child, the Father had taken the child home for his wife's protection, and on Tuesday last, business called him from home to Aylsham Fair, leaving the innocent child in his wife's charge. It appears that the murder was committed early in the morning, on account of her having been seen backwards and forwards in a state of intoxication from nine or ten o'clock; till at length Drink overcame her,

that she could not conceal the murder any longer; she went to an acquaintance to get something to drink, where she sent for a pint of gin, and said, they would take the Parting Glass, for they would not see her any more. The parties present were struck with surprise and asked her what she meant, she told them she had Killed the Child. A young person in the house with others immediately ran to the residence of Charlotte Yaxley, and on entering the premises found the innocent babe lying lifeless in the Cradle. The child is about 14 months old.

A coroner's inquest sat over the body of the child on Tuesday evening, at the King's Head Inn, Market Place, and after a long investigation adjourned till Thursday evening, at seven o'clock, when they again met, and at eleven o'clock, returned a verdict of Wilful Murder against Charlotte Yaxley.

On Friday at four o'clock she was taken before the Magistrates at the Police Office, and after a long investigation of four hours, was asked what she had to say, she said, she was born to be hanged. She was then committed to take her trial at the next Norwich Assizes.

Charlotte Yaxley is a native of Norwich and has been married to John Yaxley about seven months, her maiden name was Charlotte Gunton.

In spite of its claim to be 'true and correct', there are several errors in this broadsheet, which was no doubt compiled in haste, but the basic facts are correct: a young child had been murdered. Her real name was Lavinia Kerrison.

THE INQUEST

The inquest on Lavinia was held at the King's Head, and the full story came to light. Mary Kerrison said that she was the mother of Lavinia, whose body the jury had just seen. The father was John Yaxley, The child had been living with her father for the last three weeks, Mary having last seen her the previous Saturday — when she was perfectly well. Yaxley wanted to care for the child so he stopped giving Mary financial support, and his new wife knew the situation.

Sarah Ann Yaxley (wife of John Yaxley's brother, Charles) gave crucial evidence:

I went to John Yaxley's house; his wife was not at home; I went in and found the child in the cradle, it was dead; I sent for my mother, she came, and just after she came John Yaxley's wife came home; I asked her what she had done; my mother was there and several other persons; John Yaxley's wife said to me, 'Don't cry, the child is happy; I have done it'; I asked her what she had done? she said she had drowned it; my mother and Mr Bayly were present; my mother had gone for Mr Bayly who

came. When I asked John Yaxley's wife what she had done it for, she said she would not resolve that question; I asked whether she had done it because she had anything against the child; she said, 'No'; I said did you because you have anything against me; she said, 'No'. I said, 'What did you do it for?': she said, 'There is no one knows but myself.

Sarah Ann told the inquest that Mary had registered the birth of her baby with the Civil Registrar, but had not given the father's name. The child was also 'named' at the Ranters' Chapel (this means the chapel of the Primitive Methodists).

John Bayly was the surgeon that had been summoned, and he had found the child naked on the cradle and quite dead — the body was cold. When Mrs Yaxley turned up, she appeared to be drunk and at once said that she had drowned the child, but she refused to say where. Bayly asked when the child had been taken ill, she replied, 'She was not ill at all, I drowned the child'. Mary Kerrison was re-called, and she said that she did not stop in the room when Bayly came.

Frances Kerrison, Mary's mother, said that her daughter was twenty-two years old and had been working in 'the factory' for the last five or six years. (The 'factory' was Grout's silk factory, founded in 1818 by the Grout brothers, inventors of Norwich crepe, and employing as many as 1,100 Yarmouth girls.) Mary knew that her daughter was pregnant, but had not seen her during the pregnancy, and she did not live at home but in lodgings. She had seen Lavinia in the Market Place the previous day, and that was the last time she saw her granddaughter alive.

Frances had been sent for by Anne Diggens, and as soon as she had looked at the child's body, she went to fetch Mr Bayly. When Mrs Yaxley came home, 'she appeared as though she had no senses; she came in wringing her hands and said, 'I shall be punished, I have drowned the child'.

Charlotte Yaxley herself took the stand. She was cautioned by the coroner not to answer any questions that might incriminate her. She said that she lived on the Denes, and that she knew who the child was, saying, however, 'I don't know who is the father of the child; it is unknown to me. The child has lived with me three weeks; she laid the child to my husband and I took the child. I lived with Mary Kerrison before I married. I don't wish to answer your question as to when I last saw the child alive; I don't mean to answer any questions about the subject now under investigation. My husband wasn't at home this morning; he went out yesterday. I last saw Mary Kerrison, the mother of the child, on Saturday; had very little conversation.'

The inquest continued on the following day, Thursday. Harry Worship, a surgeon, testified that he had examined the body of the child, which was in very good health and remarkable for its good form and condition. There were no marks

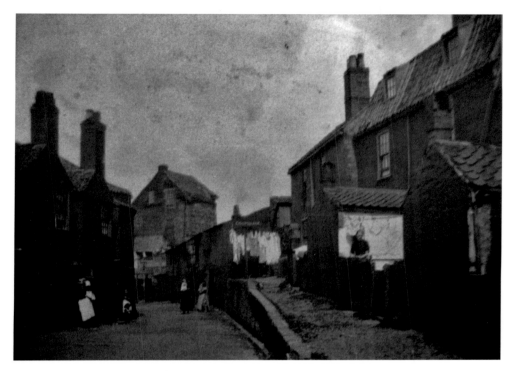

The backyards of houses in the Victorian town

of violence. When he turned the body over, a fluid mixed with froth escaped from the mouth and nose. There were no internal injuries but the stomach and lungs contained a watery froth. Another surgeon, Charles Cory Aldred, also examined the body and gave the same evidence: no sign of disease or of violence.

John Yaxley, the baby's father, then gave evidence:

I am a labourer and a married man. I was married at the church to Charlotte Middleton, the prisoner. I don't recollect when. A parson married us, but I don't know who it was. I swear I was married; I paid the money. I know Mary Kerrison; I knew her before I married; she had a child by me; I knew the child; the child was taken to my house, with my knowledge, by my wife. Mary Kerrison never asked me for any support for my child; she asked my wife for it. I paid several shillings for it. My wife told me she asked for the money, and asked me if I would allow her anything; I said I would allow a shilling a week. I saw the child last on Monday morning before I left my home. I had no conversation with my wife at that time more than usual. I told her where I was going; she knew that two or three days before; she did not ask to go with me. I did not quarrel with her; I had no conversation about the child. I came home on Tuesday night between nine and one o'clock. When I was

told what had been done, I could hardly stand or speak, I was so overcome. Some people told me my child was dead.

Mary, the wife of Richard Church, was next:

I live in the Globe Row, where my husband resides. I know Charlotte Yaxley; the last time I saw her was on Tuesday; she came to my house about half past twelve o'clock with Mary Bracey, daughter of the woman that keeps the Huntsman and Horn; had no conversation with her when she first came in; I had not seen her before for six years. She said, 'Had I been ruled by you, Mrs Church, I should never have happened of what I have. Mrs Bracey said, 'We have come to bid you farewell, and let us have half a pint of gin'. While I was gone for the gin, Charlotte Yaxley dropped down and went to sleep. I knew nothing of what had happened, but thought she had fallen out with her husband. When Charlotte Yaxley awoke, I was there; she said to the girl that awoke her, 'Come, don't let's stop here, let's go home'. She was sick, and went into the back yard, and Elizabeth Parker went to her at her request.

After they came in, Parker said, 'What do you think Mrs Yaxley has been saying to me; she says she has murdered her child, she has drowned it'. I said, 'I can't think anything of that; you are tipsy, Charlotte, you have no child.' She said, 'Mrs Church, I have a child; I take care of one belonging to my husband'. I did not know she had that child. She said, 'I drowned that child before my door at half past seven'. Then I said, 'That could not be, Charlotte, you have no child, or the policeman would have been after you before', She said, 'The police know nothing about it. I took it out of the pond and into the cradle'. I said, 'Were you tipsy when you did it, Charlotte?' She said, 'No, Mrs Church, I was as sober as you are this moment.' Well, says I, 'How came you to do it?' She said, 'I have taken several blows from my husband on account of the child, and I'll never take another'. She said, 'My husband and I fell out about going to Aylsham fair'. She said, 'I have done it, Mrs Church, and if I were to strip you would see the marks of his blows on my side.' Then I told Francis Williams to go and see. I gave no alarm to the police.

The final witness was Henry Cullingford, the policeman who took Charlotte into custody. He stated, 'She told me she wished to have her life destroyed. She was not very sober nor very drunk. She said 'I have done the murder'; she would not say why she did it, only that that was the way to destroy her own life'.

The inquest jury returned a verdict of wilful murder.

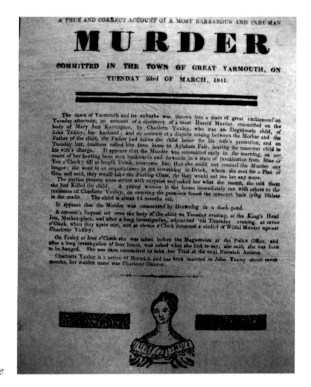

Broadside in the Yaxley case

THE TRIAL

Yarmouth Sessions had lost its power to try capital cases, so Charlotte was taken to Norwich Castle prison to await trial at the next assizes. These were held twice a year, so a suspect might have to wait up to six months in gaol before the time came for their trial. However, Charlotte had only a very short time to wait. On 4 April, less than two weeks after the inquest, she was in the dock at the Shire Hall in Norwich accused of murder. She pleaded 'not guilty'.

The prosecution was led by Mr Palmer, the defence by Sidney Taylor, who, in view of the evidence and Charlotte's own confessions to the crime, clearly had a very difficult task. Palmer stressed that Lavinia was very healthy and, although she could not run alone, was able to push herself around the room in a chair, or to go round the room from chair to chair. The couple lived in a tiny house on the Denes, by Market Gates:

There were but two rooms in his house, and these on what was called the ground floor, the keeping room being up of one step from a passage, and the sleeping room being up of another from the keeping room, there being no upstairs room. There

43

was also a place in which the husband kept his herrings, and a place where he kept ducks. This latter was a sort of yard 'paled in', with a pond or pool in it, and in which there was at the time it was examined something like six inches of water, the entrance being by a gate on one side.

A Mr Holly produced a plan and swore that it was correct. Cross-examined by Taylor, he said:

> The water in the duck pond was very muddy when I saw it; the back windows in another street would overlook the pond; there is one window in a cottage occupied by Mr Thompson that overlooks the premises and the pond, and another of three cottages that overlooks the yard but you cannot see the duck pond; the height of the pales inclosing the yard are three feet two; the pond was four feet six by six feet two, and about six inches deep.

The witnesses for the prosecution were then called. First to take the stand was Sarah Ann Yaxley. She lived just across the passage. She said that John and Charlotte had been married for seven or eight months and had looked after Lavinia for the last three weeks. On the evening before the murder, she had been in the house and seen the baby asleep in its cradle in the bedroom.

On the day of the murder, Charlotte had called on Sarah at 7.45 a.m. and once again half an hour later, this time bringing a cup of tea. On drinking it, Sarah found that it contained brandy. Charlotte came back once more at 9.30 a.m. and this time waited for Sarah's husband to go. Then the two women began to talk. Charlotte said she thought she would go after her husband. When Sarah asked her why she should want to do that, Charlotte burst into tears and said that the child was dead. 'I asked her,' Sarah said, "How came it dead?" and she said, 'It was drowned".' Sarah, naturally, got up to look for herself, but Charlotte pulled her back. However, Charlotte left after about ten minutes and Sarah took action:

> I then washed up my breakfast things, and got my babe to sleep; I went to prisoner's house, the prisoner was not at home; I opened the bedroom door and went so far as the foot of the bed; I could see the cradle, I saw the child lay there covered up; I could see the little forehead; I thought it looked dead; from there I went to my husband went to tell him; when I came back I went to Mrs Diggens, she was not at home, soon after I saw her crossing the Denes.

Sarah and Mrs Diggens went to the house, and the time was now about 12.30 p.m. They examined the body of Lavinia, who was wearing only a nightcap and was

clearly dead. Sarah then found the child's mother, who came at about 2.30 p.m. At about 4 p.m., Charlotte returned, 'led by the girls Parker, Williams and Bracey'.

Taylor got Sarah to agree that Lavinia's body and nightcap were clean, while the duck pond was just a muddy puddle — if you put clothes in it they would be fouled. Sarah also agreed with his claim that the couple got on well. Indeed, Sarah had been in the yard when John set off for Aylsham Fair and 'they appeared to very friendly together'. She said that Charlotte had treated the baby kindly and that she was not given to drink.

The second prosecution witness was Anne Diggens, who lived close by at Market Gate. She added only the detail that when she looked at Lavinia's body, the stomach was swollen (the surgeon, Bayly, had also noticed this) — her first thought was that the baby had been poisoned. She was there when Charlotte came home drunk and had said to her, 'You hard-hearted woman, what have you done?' Charlotte flew at her, screaming out, 'I will serve you as I have that', or 'I'll take your life as I have that.' Cross-examined, she agreed that the pond was dirty and had to accept that her own position was an irregular one. She said, 'I live with James Yaxley (another brother), but without bearing his name. I am a married woman.' In fact, her legal husband, Mr Diggens, lived in Lowestoft.

Next on the stand was Lavinia's mother, Mary Kerrison. She said that John Yaxley was the father of her baby, and that Charlotte had lived with her for 'eight months and a fortnight'. John had given her financial support but this had stopped when he married Charlotte, and a fortnight after the marriage he took Lavinia from her. She went to him and took the baby — a tug-of-love child — back, and John did give her 1s a week for a while. However, he soon gave this up and the child went back to him 'a fortnight and three days' ago. She too worked in the factory. She repeated the conversation she had had with Charlotte when she came back to the house drunk. She also gave a crucial new piece of evidence: when she was alone in the house, she had found the baby's clothes wrapped up in Charlotte's mantle and hidden under a large chest — the mantle was dry but the baby's night gown and shift were quite wet. However, she did agree with the defence counsel that anything that had been in the duck pond would be dirty, but that the clothes she saw had been clean. The prosecution hastily intervened to say that they could have been washed and wrung out, to which she replied that she could not tell whether this was the case or not.

Bayly repeated his medical evidence. At first he said that Charlotte had not been so drunk as to not know what she was saying, but admitted that she was 'very intoxicated'. He had seen no signs of dripping muddy water. He made the telling point that it would be impossible to tell if the water in Lavinia's stomach had originally been clean or dirty, as it had inevitably become mixed with the food in the stomach at the time.

The prosecution now produced two 'eye-witnesses' who had not been at the inquest, but their evidence was suggestive rather than crucial. Samuel Brewer was a Yarmouth carter. On the Tuesday morning, he 'went to a well for a pail of water; had to pass Yaxley's about eight yards from the end of the passage; heard the ducks making a noise; saw Charlotte standing in the lower part of the yard against a post, about four yards from the duck pond; she had Lavinia in her arms; the clock had just struck seven; the child seemed to have on a night gown.' About this time, he had spoken to a man named Swan. Cross-examined, Brewer said that she was still standing there when he came back from the pump. Swan had said he could not think why Charlotte was standing in the passage. The judge was not impressed with this new 'evidence', intervening to say that the pump might be a hundred yards away! Swan's own evidence merely confirmed that he had seen a woman in the passage with a child in her arms.

The young women who had helped Charlotte home that afternoon now gave their evidence, and revealed more about the kind of world in which Charlotte lived. Mary Anne Bracey lived at the Huntsman and Horn at the North Gate. On the day of the murder, Charlotte came into the pub. They shared a pint of gin, and Charlotte called for another one — this was at 11.30 in the morning! The two went into the Market Place as far as the Feathers, but then turned back and went to Mrs Church's in Globe Row. There Charlotte ordered a half pint of gin, but collapsed before drinking it.

Elizabeth Parker said that Charlotte was asleep there for two hours and that when she woke up she was sick in the back yard — Parker had held her head. Cross-examined, she said about the Churches, 'He sells sticks; she keeps girls — I am one of them.' She stressed that Mary Anne Bracey was not one of the kept girls. Elizabeth had lived at the house for a year and had seen Charlotte there — but never since she had married. Frances Williams admitted to the defence counsel, 'I live at Mrs Church's: it is a very low house.'

Mrs Church confirmed that Elizabeth Parker and Frances Williams were 'unfortunate girls', but said that she had never seen Mary Anne Bracey before she came to the house with Charlotte on the day of the murder. She, too, had not spoken to Charlotte since her marriage. It sounds as if Charlotte had been able to escape from the world of Globe Row by her marriage to John Yaxley, but at the price of having to become 'mother' to his illegitimate child. Sadly, for her this was too high a price to pay.

Worship repeated his inquest evidence, saying that in his opinion the baby died from drowning. However, Aldred was now less certain and thought that death could have been from drowning or from suffocation. In the latter case, she would have been put into the water afterwards. Cross-examined, he agreed that the water in the child's body was quite clean. Obviously fearing the possibility that

the jury might think Lavinia could have died from natural causes, the prosecution got him to say, 'the child certainly did not die either of apoplexy or epilepsy'.

The prosecution had finished their case. Taylor called no witnesses for the defence, but spoke for one hour and forty minutes. The jury would need to consider, he argued, whether there had been violence at all, and if so, if it had been done by the prisoner of her own wilful mind. He pointed to the difference between the opinions of the two surgeons. Aldred accepted the possibility that the child might have suffocated through being overlaid. It might have been this that led Charlotte to begin drinking brandy that morning, and go on to get drunk, so she might have been literally out of her mind when she made her confessions. He pointed out that there were no signs of violence at all — surely the baby would have struggled if Charlotte had dried to drown it — and reverted to the cleanliness of the clothes.

Summing up, the judge said that the jury must not be deterred from giving their verdict because of the heavy penalty attached to the crime. The jury deliberated for just fifteen minutes before their verdict of 'guilty'. The judge said that in a murder case he very rarely gave any other sentence than death, but that in this case he would sentence Charlotte Yaxley to transportation for life. She was one of 180 convicts who left on the transport ship *Garland Grove* on 14 June 1841. We know that she arrived safely in Van Diemen's Land, but she then disappears from history.

Another child murder took place a half-century later in Ormesby, then a separate community but now part of Greater Yarmouth. Eveline Smith, a domestic servant aged just seventeen, was charged with killing her unnamed male child on 27 April 1909. She was tried in Norwich at the same assizes as Allen, Alger's killer, whose case is described later, in October 1909. Eveline was living with her parents. She was not known to be pregnant, and showed no signs, but on that particular day she became very ill. Her father knew the cure — he went out to get some gin. Presumably the pub proved too strong an attraction as he did not return, and Eveline's mother went to find him and the 'healing' gin. While she was out, Eveline gave birth alone. She severed the umbilical cord, and then she took a brass candlestick that happened to be in the room and hit the newborn baby on the head, hiding the body under her bed. When her mother came back, she was in bed, and the sheets were stained with blood. Inevitably, the truth soon came out. However, the case took a somewhat surprising turn. The medical expert, Dr Blake, said that the child had not lived more than a minute, and he could not definitely swear that the child had had a separate existence. The prosecutor said that, in view of this evidence, he would not go on with the charge of murder, and he did not wish to even proceed with the lesser charge, that of concealment of a birth. Under these circumstances, the judge directed the jury to find Eveline 'not guilty'. They did so, and Eveline Smith was discharged.

CHAPTER 10

Death of a Shopkeeper: the Murder Of Harriet Candler

The death of Harriet Candler and the tracking down of her murderer was the most dramatic of the mid-Victorian murder cases. It involved two full scale trials, with the main prosecution witness in the first becoming the accused in the second, and ended in the most spectacular of the public executions of the period.

THE MURDER

On the morning of Tuesday 19 November 1844, the body of a dead woman was found in a shop in Great Yarmouth. The shop sold groceries and was in Howard Street, at the south-east corner of Row 52, and not far from the still-standing Market Row. Harriet Candler, a forty-eight-year-old widow, ran the shop and it was her body that was found. It was a large house. Mrs Candler lived alone on the ground floor, the first floor was occupied by Mr Catchpole, a solicitor, and, as the local press noted, 'Above his offices a man and woman named Yarham live, who take care of the premises. It is remarkable that Mr Yarham, on the night of the murder, was sitting up for Mr Catchpole till 1.30 a.m. in the morning, in a small room separated only by a board partition and a passage from Mrs Candler's apartment.'

The discovery was made at 2 a.m. by two policemen who were trying the doors and shutters, as was their custom. The shop door was closed but not locked. When one policeman tried it, it opened, and he went into the shop. Nothing seemed to be disturbed, but he called his partner in. He looked into the bedroom and the yard but there was no one there. It was only on going to look at the till that he stepped into a pool of blood. Looking down, he saw the woman nearly under the counter: her throat had been cut. While the authorities were summoned, one policeman looked around the shop. The till drawer had been taken out and was on the floor. It was empty. There was a table knife near the body covered with blood.

Globe Row, scene of the brothel mentioned in the Yaxley and Yarham cases

The police made enquiries and found that it was known that Mrs Candler had been in possession of a great deal of money: she had received £50 a week before and £150 the previous Saturday, consisting of a cheque for £100 and five ten-pound notes. This was her share of a family legacy. It was naturally assumed that she had been murdered for this money, but when the house was searched the cheque and the five ten-pound notes were found in a chest of drawers in her bedroom.

On the same day that the body was discovered, a married couple called John and Sarah Dick came into the story (the name is also spelled Dicks, Deek and Deck in the trial records, a good example of how variable spelling has been until very recent times). Dick was a gunner at the Town Battery. That afternoon, he came into the police station with a bag of money and a strange story to tell. His wife had been out on the Denes with a basket of linen that morning when she saw some holes in the sand. Digging into the sand with one with her hands, she found a large bag containing a lot of money in copper. On the outside was a label with Mrs Candler's name on it. Mr Dick saw his wife digging and, hearing her shriek, he ran across and pulled the bag out of the hole.

A new character now appears: Robert Royal, a local fish dealer. He came up to Mrs Dick on the beach and, according to her statement, he said, 'There is more in this hole, let us feel'. Robert pulled out a small bag containing gold and silver. According to Mrs Dick, he then said, 'There ought to be a cheque too',

and feeling in the bag he said, 'Here it is'. Royal tried to take the money to count it, but Dick prevented him and took the bags to the police station. Royal went with them, and, when he got there and the story was told, he was detained on suspicion. He had blood on his clothes, which he explained by saying that he had been fighting with a man at the Half Moon public house. The police already knew Royal as one of a gang of thieves and rounded up the others: Jeremiah Cooper, James Hall, James Hubbard, and Samuel Layton, alias Belcher Layton. The bag contained not a cheque, but a piece of paper on which was written a text of scripture.

THE INQUEST

Still on that same day, the inquest was held. The jurors viewed the body lying in blood in the shop and then assembled in the court at the (old) town hall to hear the witnesses. A Mr Swan identified the body. He had known Harriet for years and was the man who had dealt with her share of the legacy. Other members of her family confirmed the legacy story. John Coe and Mr Botwight of the Black Swan opposite her shop also gave evidence They had last seen Harriet at eleven the previous night when she had called into their pub for some beer, as was her custom.

A friend, Lilian Cousins, said she had visited the previous evening, leaving her at about 7 p.m. Another friend, Margaret Edwards, had seen her as late as a few minutes before eleven when she had seemed very cheerful, saying that she had received a legacy, although it not been as much as she had hoped. She confided that she had hidden the money under her bed. The police medical evidence followed: Harriet Candler had died from being hit about the head with something like the head and claw of a hammer. The wound on the neck was inflicted when she was already down on the ground. The verdict: 'murder by person or persons unknown'.

The five men who had been arrested were questioned at length, but with no result. All were discharged over the next two days. During the following week a man named Mapes was apprehended and examined, but he too was discharged. In early December, Yarham was detained along with his family — his wife, mother, and two sisters. Some people thought the handwriting of the text in the bag was that of Yarham's mother. Royal was also detained. Yarham then made a written statement. He had let two men into the house via the yard of the Black Swan to rob Mrs Candler. He said that they were Robert Royal and a man called 'Jigger' Hall (both were well known to the police). Afterwards he saw Royal on the street. Royal said that they had knocked the woman on the head. Yarham

The execution of Samuel Yarham

cried out, 'Good God you have not murdered the woman?' Royal threatened do to the same to Yarham — and also offered him a sovereign to say nothing about it. Hall was found and Mapes re-arrested; Royal was already in custody.

Yarham, his wife, Royal, Hall and Mapes were all held in custody over Christmas 1844. They were interviewed by the magistrates in early January, but the press was not allowed to attend. A new witness, John Sayer, stated that he had seen Royal, Mapes and a man he did not know, but who looked very like Hall, together in the Market Place on the fatal night; he knew the exact time, as at that moment he heard the chapel clock strike eleven. Later, Sayer complained to the magistrates that he had been threatened in the Market Place by a gang led by Royal's father, who said that his son would never have been committed but for Sayer's evidence. Yarham repeated his testimony against Royal and said that he was with a man whom Yarham could not see clearly but who was called 'Jigger' by Royal. However, other witnesses said that Royal had been in the Half Moon throughout the evening, and that Hall had been in at the Feathers all the evening apart from a brief outing to talk to a man near the Silk Mills about pigeons, returning to the pub by twenty past ten. Mapes also produced witnesses to claim he had an alibi, but his witnesses were inconsistent as to times. All four men were

committed for trial, Yarham as an accessory after the fact. However, when the trial came, Yarham was not to be one of the accused but the chief prosecution witness.

THE FIRST TRIAL

The trial was held in Norwich on 7 April 1845. Robert Royal (twenty-four), James Hall (twenty-four) and James Mapes (twenty-one) were charged with murder; all three mean pleaded 'not guilty'. Naturally, the key witness was Yarham. His story was that on hearing a noise in the shop, he went out into the street:

> I saw two men one of whom was crossing the street and the other coming out of Mrs Chandler's shop door; the man across had a bundle under his arm; the other put up his hand to remove an obstruction and pulled the door after him; the man who drew the door to was Royal, whom I have known from a child. I said, 'Royal, what are you about?' He said, 'Go on Jicky' or Jigger, I don't know which. Royal then said to me, 'B ...t you, if you say anything I'll serve you out'. He said this twice and made other threats and promises.

Yarham went into the shop and saw the body. He let Mr Catchpole in about 1.30 and answered the policeman's call at about 3 a.m. Cross-examined, he admitted that he had not told the police this story at once and said that was because he was afraid of Royal. The defence counsel implied that he was getting his revenge on Royal who had beaten him up as a child, but he denied this. The alibis were, as before, for Royal and Hall. Mapes' alibi was not so strong as theirs, as several people had seen him in the King's Head but were unsure as to when he came and when he went. It appears that he had left the pub, been to the Barge and the Queen's Head and the Freemasons' Arms, and spent the key part of the night in the brothel in Globe Row with a girl named Jane Whitaker. He had been there between midnight and 1.30 a.m.

Mr Prendegast for the defence denounced both Yarham and his wife — not only were they of the criminal classes, they were socialists! 'Now who was Yarham?' Mr Prendegast asked. He continued:

> A man who had been denounced by the counsel for the prosecution as a man of great moral depravity, who had been convicted of a felony before. But then Mrs Yarham was called to his assistance and she also had been the inmate of a prison twice, and must have been strongly suspected. Now again, he would repeat, 'who was Mrs Yarham? They had heard in London of a body called Socialists, who

openly inculcated there was no moral responsibility, nor anything binding in it at all. This woman attended these meetings — meetings of people who declared there was no God, no Eternal Being, no life but the present. That woman said she had been to these meetings, and heard Mr Owen lecture, and that her husband accompanied her to these places, although he said that he had never attended one. But letting that discrepancy pass, she admitted she was the wife of a man who sold Socialist publications; she went to the meeting and admits her first husband sold a publication called the Crisis. Who then was to trust her?

One wonders if the spectre of socialism really frightened a Norwich jury even in 1845? In any case, her first husband had been a bookseller in London not in Yarmouth, and had been dead ten years. She had been married to Yarham for eight years, so this was nothing more than a deliberate blackening of Sarah Yarham's character. Mapes' counsel, Mr Couch, avoided the politics and struck to straight accusations, saying, 'He thought that if they would but go with him through the evidence they would see that Yarham himself was the murderer, who now came into the box and sought to swear away the lives of the three prisoners at the bar.'

Sarah Yarham's evidence in fact added nothing new. She had been unwell on the night of the murder and had applied leeches to herself. Her husband had come up to the bedroom at about 11 p.m. for few minutes, and again at about 1.30 in the morning, and after that the bell rang. William Catchpole also spoke, but he too had nothing new to add. He had dined out, coming back about 1.30 a.m. Yarham opened the door for him and got him a candle. He went to bed, only to be woken in the night by the ringing of the bell.

John Bales, a Yarmouth sergeant-at-mace (a court official), had evidence to offer that would seem to condemn Yarham. He had seen the footprints on the beach and he thought that some were Yarham's — apparently he had exceptionally small feet! Several people had seen two men go to the beach at about seven in the morning after the murder. One was Royal, but no one was able to say who the other was. Perhaps it was 'Jigger' — or perhaps it was Yarham himself! Bales had also searched Yarham's house, looking through his shoemaking tools; Yarham's hammer was missing. In fact, Bales appears to have exceeded his duties, not least by supplying a plan of the premises to Hall's defence counsel, which got him into trouble with the Yarmouth magistrates, some of whom wanted him dismissed, others merely wanting him suspended for six months. Dismissal was decided upon by eleven votes to three.

Meanwhile, in Norwich the jury conferred and returned their verdict 'not guilty'. The three men were cheered and when Yarham returned to Yarmouth, the police had to be called to protect him from the angry crowd.

THE SECOND TRIAL

Nine months later, on 8 January 1846, Yarham was re-arrested. He was tried for the murder at the Norwich Assizes on 27 March. It was Sarah Dick who gave the crucial evidence that led to Yarham's re-arrest. She said that not only had Royal been looking for the money on the beach, but so had Yarham, and not only that but he had confessed to her that very day that he was the murderer! At about 5 p.m., she saw a man looking at the holes where the money had been (in fact, it had already been taken to the police station by Mr Dick, as we have seen). She did not know him, but knew him now to be Yarham. He came into the battery and commented on how cold it was. She remembered his remarks by heart:

'Are you the woman that found the money?' She said that she was.

'Well, all you have to do now is find out the murderer.' She answered that, lame as she was, she would walk twenty miles to find him out.

He then said, moving his foot in the sand, 'I am the murderer'. She laughed at him, saying that if he were the murderer he would not come here telling her all about it.

He said, 'Well, do you know me?' and when she replied that she did not, he said, 'You do'. She said to him, 'Tell me your name and I'll tell the gentlemen what you say.' 'He then walked away, rubbed his face looked at me and then went away altogether.

Clearly this was stunning evidence, and there was corroboration for Sarah Dick's story. She said that she had not been alone: her daughter and a boy called Seaman had also been in the battery. She also said that when she tried to report this conversation to the mayor he had stopped her, saying it was just someone tampering with her to prevent the ends of justice. Mrs Dick now claimed to have had two more conversations with Yarham. She had gone to the previous trial as a witness, and went back to Yarmouth by train. While she was waiting at the station, Yarham and his wife came up to her. As they were approaching, she said to her husband, 'If that is Yarham, that is the man I saw on the battery and who told me he was the murderer.' Yarham wanted to shake hands with her husband, but Dick refused. They got into the train and Yarham handed her a carpet stool to sit on (there were no seats for passengers in third class!) Sarah Yarham asked Mrs Dick if Yarmouth people would think they were guilty.

Mrs Dick met Yarham again in Yarmouth Market Place a fortnight or three weeks after the trial. He asked if Royal and the others had threatened her. She said no, but they had pressured her daughter, and she asked if they had got at him. Yarham said that Hall, Mapes and Royal dared not interfere with him, but that the people of Yarmouth blamed him and he had been to the workhouse to

get some money to enable him to leave the town. She was unsympathetic, saying that he was either the murderer or he knew who the murderer was.

Yarham then, or so she claimed, told her the full story.

Stop, bor, [a good Norfolk phrase!] and I will tell you about it. I was not so much to be blamed as the others were, for after they knew that Mrs Candler had the money, they would not let me rest. They heard that my master was going to the Angel on that night, and they made a bargain that I was to let them in, but they were not to hurt the old woman, I told them there would be plenty of time for them to get the money while she was gone for her beer, as she was generally gone for ten minutes or a quarter of an hour. It was so arranged and he let them in at the back door; Royal watched outside while the old woman went for the beer; they went into the old woman's room and sat down on the bed; the old woman sat down by the fire; Royal made a scuffling noise and the old woman went into the shop and she said, 'O it is you Royal, what do you want?' He said, 'half an ounce of tobacco'. Royal then knocked her down, and Hall, who had a pair of pincers in his hand, struck her on the head with them; it was not my hammer but Jigger Halls' pincers that did it.

Then, Yarham apparently continued, the others went out to hide the money, but he decided to leave this to them and returned to the house. When he came back, Harriet was still alive, lying in her own blood on the floor, moaning, so he took up the knife and cut her throat. Mrs Dick said that she had replied that he *was* the murderer then, but Yarmouth then claimed that Harriet would have died in any case.

Sarah Dick said she had told her husband about this conversation, but he ordered her not to spread it about — as a professional soldier, he did not want any involvement in the lives of the citizens of the town. As a result, it was about three months before she finally told the magistrates. She knew the trial had excited much interest but she could not read, so had not seen the reports in the newspapers. Her story was supported by her daughter Sarah, who said that on that occasion in the battery she had asked the boy, William Seaman, who the man was. He had climbed on the gate to have a better look and had said, 'That is Yarham'. Seaman agreed. He already knew Yarham, having seen him at Catchpole's house.

Yarham's defence was conducted by a Mr Dasent. He had only been called in at the last minute, as Yarham's friends had had great difficulty raising the money needed for his fee. He had not even had time to read the case papers. He condemned the way the Yarmouth magistrates had handled the case, but he produced no defence witnesses. All he could do was to try and discredit Mrs Dick. 'Who was there who could place any credit on her statement? At the last

trial she had kept back a most important piece of evidence; she actually went into that box to swear away the lives of three men, and all the time knew that she could point out the murderer, according to her own evidence. On that occasion she was sworn to speak the truth, the whole truth and nothing but the truth, and yet she had not said a word about the conversation at the battery.' Dasent then referred to the conversations in the train and in the Market Place: these were exceedingly improbable, and were doubtless fabrications of her own, made up from the newspapers. Having stated his entire disbelief of every word of that statement, and the improbability of the murderer making such a confession to any person, more particularly the witness, he concluded by an eloquent appeal to the jury to take a favourable view of the case.

The jury came back after just ten minutes with the verdict of 'guilty'; Yarham was sentenced to death.

THE EXECUTION

After the verdict, Yarham's background was described in the press. He was brought up by parents who were poor but pious: they were Wesleyan Methodists. He went to the Lancastrian School in Yarmouth until he was about fourteen. He then went to London, where he lived with a relative by marriage, Edward Harvey. Harvey was an active atheist who held meetings on the subject at his house and who sold blasphemous books by Thomas Paine and others. While in London, Yarham married Sarah Steins, the widow of another publisher of such books. After three years of marriage they came back to Yarmouth, and about two years after his return he was caught stealing a bible and a geography book, for which he was sentenced to a month's imprisonment. It was this one crime that allowed his enemies to portray Yarham as a habitual criminal.

Yarham wrote from prison to his wife and his parents maintaining his innocence: he had never spoken to Mrs Dick except on the train, and even then it had been his wife who had done the talking. He called on God to witness that he had not spoken to Royal for ten or twelve years, and had not even seen him for several months before he saw him coming out of Mrs Candler's house, and the other two men, he said, he did not know at all.

He was executed on Saturday 11 April 1846. In the morning he attended the prison chapel, received the sacrament, passed a few moments in prayer before 'the drop'. There was no sound from the crowd 'except one simultaneous buzz which generally accompanies the instantaneous recognition of such a criminal. Silence then reigned and on the instant of the execution the Hill rapidly cleared of the great proportion of the spectators.'

In fact, this was the day of the Tombland Fair, so the city was crowded and the numbers watching the execution far greater than normal. *The Norfolk News*, a newspaper opposed to capital punishment (unusual, at that date), summed up the situation:

A hanging and a fair, death and buffoonery, the functions of the executioner and the freaks of the Harlequin, were the sights then furnished in immediate succession, and on the same spot, for the edification ad amusement of the multitude. Over 4,000 people came up by trains on the Brandon line, including 800 on one train from Wymondham: cattle trucks had to be used to carry them. Over 1,500 came on the line from Yarmouth. Every road leading to the city was covered with pedestrians, besides vehicles of all kinds crowded with people: by 11 o'clock there were between 20,000 and 30,000 persons on the Castle Hill, cramming the space between the Castle Inn and Shire Hall.

The crowd watched the hanging in silence, but then, as the *Norfolk Chronicle* tells us:

After the execution, gongs, drums and other instruments commenced their uproar, mountebanks and clowns their antics, the vendor of wares ad exhibitors of prodigies their cries, while the whirligigs and ups-and-downs were soon in full swing. The public-houses round the Hill were crowded, and hundreds finished the day in riot and intoxication.

Royal and Hall were on the hill during the execution, and got jostled about by the crowd. They were turned out of the Golden Ball and other public houses where they presented themselves.

There seems no doubt that both Yarham and Royal were heavily involved in the crime, as Royal's presence on the beach on the morning after the murder is enough to prove his guilt. Hall was probably his associate, and the fact that both men had such clear alibis on the night is suspicious in itself, as though their associates had been rehearsed in places and times. On these grounds, perhaps Mapes was not actually involved in the crime. He was not mentioned in Yarham's statement and his confused 'alibi' does not sound as if it had been prepared in advance! And what of Sarah Dick? If Yarham had really confessed to her on the day of the murder, she clearly concealed vital evidence at the first trial. The second confession in the Market Place also sounds extraordinary but there is a possible explanation. Yarham may have thought that, having turned Queen's evidence, he could not then be prosecuted for the same offence. If he thought this then he was boasting rather than confessing — and he was soon to be undeceived! Or

perhaps Yarham the liar was himself undone by lies. He had been happy enough to tell untruths to see Royal and his mates hanged, so perhaps Royal had bullied Mrs Dick into telling lies that were to hang Yarham. Her story of the knife being used to actually kill Mrs Candler matches the evidence of the medical expert that she was already on the floor when she was knifed. Whether she was told by Yarham, or put up to it by Royal, Sarah Dick's account of the death of poor Harriet Candler was as near as we will ever get to the truth.

CHAPTER 11

The Suspension Bridge Disaster

In the twenty-first century, it is fashionable to mock the work of Health and Safety officials when they appear over-zealous in insisting on detailed risk assessments for things like school outings. However, if the Yarmouth Bridge Disaster were to happen today, distressed relatives would naturally expect the bridge builders to be put on trial, imprisoned and fined — and also pay compensation to the families. In the Yarmouth of the 1840s there was no Health and Safety as we know it. Many people engaged in dangerous occupations without thinking about it, and many — seafarers, factory workers, builders — paid for it with their lives. However, the loss of so many young lives in the bridge disaster of 2 May 1845 naturally aroused a great amount of discussion. Had a crime been committed? Should there be a trial?

If you go down to the river Bure, not far from the railway station, you come to a pub beside the river called The Suspension Bridge Inn. The river here was the site of perhaps the most tragic incident in the history of Great Yarmouth. There was originally a ferry here and the owner of the ferry rights, Robert Cory, built a suspension bridge over the river in 1829. He was so proud of the bridge that he had a medal struck with a picture of the bridge on one side. The bridge was intended to open up Yarmouth to the west and this was accomplished when Cory completed the turnpike road across the marshes from Yarmouth to Acle, now known to locals as the 'Acle Straight'. This opened in 1831. In 1844, the railway station opened on the site where it is today — that is on the far side of the Bure from the town. The bridge was enlarged to take the extra traffic. Just a year later, disaster struck. The *Norfolk Chronicle* tells the story:

On the afternoon [of 2 May] Nelson, the clown at Mr Cooke's circus, had undertaken to swim in a tub, drawn by four geese, from the drawbridge on the quay to the suspension Bridge across the North river — a foolish exhibition — but it was

The fall of the bridge, from a contemporary newspaper

one which, from its novelty in Yarmouth, was calculated to attract the multitude. As early as 5 o'clock, when the train arrived from Norwich, although raining smartly, thousands of spectators had already assembled to witness the feat on both sides of the river. The Bridge was then comparatively clear. The Clown commenced his feat with the flood tide at the drawbridge, and had entered the North river. There were many persons on the Bridge, and, as he drew near, the multitude upon it endeavoured to obtain a full view as he should pass underneath. Already he had reached Bessey's wharf, not far from the Bridge, when one or two of the rods were observed to give way; an instant alarm was given to quit the bridge. Alas! The caution came too late. The chains broke, and quick as the passing thought, one entire side fell, and the entire mass of human beings, whose numbers are estimated from three to four hundred, were swept into the river below. The traffic road of the Bridge, which but an instant before was horizontal, had become nearly perpendicular. Oh who shall paint the one mighty simultaneous agonising death-scream which burst upon the affrighted multitude around re-echoing from the earth to heaven — may the appeal not be made in vain. One instant and all was hushed, save the struggling of a few whose lives it pleased their Maker in his mercy to spare. The waters, we are told, as if gifted with a sudden impulse of horror, recoiled in the impetus of the fall, and

1 Adams Robert, Rainbow Corner, aged 7
2 Augor Caroline, Garden Row - 10
3 Bussey Harriet, Ferry Boat Row - 26
4 Below George John Henry, Fuller's Hill
5 Butliant Sarah Ann, Row 2 - 9
6 Borking Emily Hanworth, George Street - 18
7 Burton Benjamin Patteson, Row 54 - 5
8 Barber Christopher, Pudding Gates - 7
9 Bradberry Isaac, King Street, Norwich - 11
10 Beckett Ann, Priory - 20
11 Barker Leonard, Surry Street, Norwich, not yet found - 8
12 Buck James Seaman, Row 17, not yet found - 22
13 Balls Reeder Thurston, Bath Place - 4
14 Church James, Rainbow Corner - 16
15 Crowe Eliza, Row 6 - 7
16 Church Caroline, Horn Row - 14
17 Conyers Elizabeth, Row 13 - 16
18 Cole Jane, Row 65 - 13
19 Durrant Wm. Row 24 - 16
20 Ditcham Mary Ann, Row 18 - 12
21 Duffield Eliza, Rainbow Corner - 64
22 Dye Charles, Moat - 10
23 Dye Benjamin, Garden Row - 2
24 Edwards Maria, Garden Row - 9
25 Ebbage David, Row 17 - 12
26 Field Hannah, Row 14 - 9
27 Fulcher James, Row 34 - 12
28 Fulcher Elizabeth, St. John's Head Row - 14
29 Funnell John, Wortwell, not yet found - 16
30 Fox John Horace, Butchers' Row - 19
31 Field Susannah, Say's Corner Row - 7
32 Gilbert Sarah, Row 14 - 12
33 Gotts Alice, Conge - 52
34 Gotts Alice, jun. - 9
35 Grimmer Wm. Moat - 8
36 Headle Wm. Ferry Boat Row - 10
37 Hann Sarah, Row 3 - 13
38 Hannibal Elizabeth Jane, Row 110 - 12
39 Elizabeth, East Hill - 11

40 Johnson Elizabeth, Row 23 - 11
41 Johnson Sarah Ann, Row 23 - 8
42 Johnson Thomas or Robert, Row 1 - 16
43 Jenkerson Mary Ann, Row 1 - 8
44 Juniper Maria, at Workhouse - 10
45 King Mary Ann, Apollo Walk - 9
46 Lucas Frederick, Row 21 - 11
47 Lake Mary Ann, George and Dragon Row - 62
48 Lyons Wm. Row 1 - 2
49 Little Harriet Mary, Market - 6
50 Livingstone Joseph, King Street - 13
51 Livingstone Matilda, King Street - 6
52 May Clara, Row 6 - 7
53 Mears Susan, Ferry Boat Row - 20
54 Manship Elizabeth, Rainbow Corner - 8
55 Morgan Elizabeth, Row 1 - 28
56 Morse Robert, Charlotte Street - 62
57 Powley Elizabeth, Row 2 - 26
58 Powley Richard, Row 3 - 21
59 Parker Charlotte, Row 13 - 4
60 Powley Amelia, White Lion Opening - 8
61 Richardson Phebe, Row 99 - 10
62 Roberts Lydia, Pudding Gates - 17
63 Roberts Mary Ann, Pudding Gates - 12
64 Read Elizabeth, Rainbow - 19
65 Scotten Ann Maria, Row 3 - 5
66 Stalworthy Maria, King's Arms Yard - 20
67 Tann Harriet, George and Dragon Row - 14
68 Tennant John, Railway Walk - 15
69 Tennant Wm. Railway Walk - 11
70 Thorpe Heppy, Row 2 - 10
71 Trory Wm. Townshend, George Street - 12
72 Thompson Mary Ann, British Lion Alley - 15
73 Utting Louisa, Row 33, not yet found - 7
74 Utting Sarah, Gaol Paved Row - 18
75 Utting Caroline, Row 23 - 9
76 Vincent Maria, Apollo Walk - 19

Lists of the dead, as published in the local press

'boiled up' at the back of the bridge, which hung perpendicularly below the surface of the river. As suddenly the struggle for life was past to all but a few.

Then came a scene scarcely less heart-rending. With an energy, activity and stern determination of purpose, which are among the wise and merciful provisions of the Almighty, 27 children, all girls, were immediately rescued alive on the west side of the river, and as instantly put to bed at the Vauxhall Gardens, who as soon as revived were replaced by others equally beneficently spared, or by some never to be recalled. On the east side, numbers of bodies were taken into the adjoining houses, where all the assistance which medical skill, humane attention, in short all the aid which humanity would teach everyone to offer, was brought to bear. Alas how often in vain. In one house alone, at nine o'clock at night, out of sixty-eight bodies carried in, only three were revived.... The search for bodies was continued till about half past nine o'clock, when the boats were compelled to desist, but before the turn of the tide nets were placed on each side of the bridge to prevent, if possible, any of the bodies not yet recovered being carried out to sea by the force of the current which is very strong.

The final death toll was seventy-nine. Most of the victims were very young, including thirty-three aged ten or less. Only sixteen of the dead were over twenty years old. Many of the dead lived very close to the scene of the disaster, over thirty coming from the Fuller's Hill and Northgate Street area. After the tragedy no one was quite sure how to proceed. There was an inquest of course, and the jurors asked the Corporation to employ an engineer to investigate the cause of the disaster. The Corporation met to discuss this. It was pointed out that Mr Stephenson had already said in the House of Commons that the bridge was not 'fit for purpose' as we would say today, but his slightly less pithy phrase was actually that it was not 'fit for the purposes for which it was intended'. He said that there was no doubt that it was because of the 'wings' that had been added to the bridge that the disaster had taken place. The Town Clerk thought there was no point in looking back, especially as the original bridge builder (Cory) was dead. Instead he looked ahead, stating that 'in future it would be wise for the Council to see what was proposed to be built, and to prevent the erection of an improper one.' Thirty years later it did indeed become the law that a Borough Council could insist on seeing plans for any building and could reject them if it thought them unsuitable.

As the Corporation would not act, the jurors asked the Home Secretary to take up the matter, and he appointed a civil engineer, James Walker, to investigate and report to the inquest.

Cory's bridge was built by a contractor, G. Goddard, to a specification prepared by Mr Green, but both these people had since died. The design had been approved by the architect J. J. Scholes. When the bridge was to be widened, Scholes was

Inquest on Ann Beckett, one of the child victims

again consulted. He recommended that footways be attached to the iron framing of the bridge — *outside* the suspending chains. The actual cause of the disaster was pinned down to one rod or bar of the suspending chain on the south side of the bridge at the east end. This suddenly snapped, and many witnesses heard the crash and saw the chain begin to part. The rods were in pairs, so that the all the weight was now on the other rod. Five minutes later, this too broke and the south side of the bridge collapsed into the water. Walker had examined the iron, and it was *not* of the first quality on which the original contract had insisted.

On 17 May, the last body was found, that of six-year-old Louisa Utting, in the water near the gasometer. The jurors took her case as an exemplar for their verdicts on all the dead and stated the following:

…that the deceased came to her death by the falling of the Suspension Bridge across the Bure in this borough on 2 May 1845: and that the falling of the bridge was attributable immediately to the defect in the joint or welding of the bar that first gave way, and to the quality of part of the iron, the workmanship being inferior to the requirements of the original contact, which had provided it should be of the first quality.

This pinned the blame by implication on Goddard, who presumably should have tested the iron. However, he was dead. In any case, he could have argued that he could hardly have been expected to allow for the fact that someone might widen his bridge. Scholes and the other people widening the bridge could themselves argue that it would have been beyond reason to expect them to anticipate a situation where every person on the bridge was standing on one of its wings! Manslaughter? Misdemeanour? Pure accident? Draw your own conclusions.

Today, only the pub marks the spot where the tragedy took place — and the pub sign does not show this bridge but a later tubular replacement. If you want to remember the tragedy, go into the churchyard, and to your right you will see the tombstone of eight-year-old George Beloe, one of the victims of the disaster. The falling of the bridge is depicted on the stone, but unfortunately the stone has become very eroded over recent years.

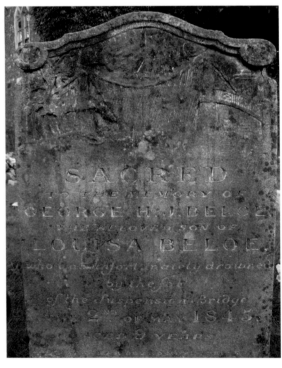

Gravestone of George Beloe

CHAPTER 12

The Sailors' Strike

The sailors of Yarmouth have been involved in fights and riots many times over the centuries, often fighting sailors from other towns. The most important of their struggles was against the Yarmouth ship-owners in 1851. It began and ended peaceably, but there was violence in between.

The story starts with a meeting between sailors and ship-owners at Yarmouth Town Hall on 14 February 1851. The sailors said they wanted to have 55s a month or voyage all the year round. At the present time they got 50s in the summer and 60s in the winter. This agreement had been in force for twenty years. Some ship-owners, such as Mr Palmer and Mr Scales, supported the sailors, but others, such as Mr Bessey and Mr Jay, did not — and Jay said that if the sailors did away with the agreement, he would consider himself at liberty to obtain men at as low wages as he could. The sailors' leaders said they had pledged not go out for less than 55s. This was followed by a peaceful procession organised by the sailors on Saturday 15 February. Several thousand sailors gathered on the quay and marched round to Victoria Parade, via Regent Street, which they more than half filled so great was their number, through the Market Place down Fuller's Hill and back along the quay. The *Norfolk Chronicle* commented that they were as quiet as if it had been a funeral procession:

> ... we do not know another town in the kingdom where so vast a multitude could be peaceably, so safely brought together, and we shall sincerely rejoice to be able always to speak as well of Yarmouth sailors.

However, trouble broke out on the following Saturday 22 February. Samuel Graystone, master of the *Ant*, bound from Yarmouth to Plymouth, had been forced by intimidation to come ashore the previous day, and he complained to the police office that he was now being prevented by the sailors from going aboard.

The old Town Hall and the adjoining quay

The master of the *Maid of the Yare* complained that four men, including John Crome, the mate, had signed articles and were willing to go on board but they dare not face the mob. A detachment of police protected the men, but those of them who did get on board were assaulted and driven ashore. In a third incident, Thomas Orme, master of the brig *Resolution*, complained against James Knights, aged nineteen, who had signed articles on 12 February to go from Yarmouth to Liverpool and received 15s in advance — and then disappeared. A warrant was issued for his arrest.

The magistrates met in emergency session. Graystone repeated that he been forced ashore, and said that he was afraid of having his head broken. He asked for protection. One magistrate, George Danby Palmer, said that they should not call in any force but their own and, if necessary, let them swear in a hundred special constables! Large crowds were collecting on the quay as the magistrates met. Crome came before them, bearing marks of violence on his face. He said that when he went on board, the mob had pursued him and thrown him off the side of the ship. The local paper took up the story:

Graystone having consented to join his ship, which was lying in Lowestoft roads, provided he could be protected thither, it was at first suggested that a post-chaise should be obtained, but it was objected that the sailors would cross by the ferry and stop him. It was then agreed that Mr Barber (Graystone's employer) should procure a steamer, bring her up to the quay at the bottom of Regent Street, and that then the magistrates and police should see him safe on board. A long delay took place in the arrival of the steamer, and the magistrates, fearing it might have been stopped, walked down the South Quay. Many knots of sailors and other persons were standing about, and frequent calls were made with a small whistle, which many of them used as a signal for collecting together. As the magistrates returned to the police office, having ascertained that the steam tug was preparing to come up to the quay, they were followed by increasing throngs. Some little time after two o'clock, it having been announced that the steamer was quite ready for the reception of Graystone, the entire police force, accompanied by the mayor and about a dozen magistrates, took him under their care, and were proceeding with him to go on board. Just as they got past the lamp column at the corner of Hall Plain, a tremendous rush was made by several hundreds of sailors to separate and capture Graystone. The mayor was collared, some of the magistrates struck, the police force furiously attacked: they succeeded, however, in capturing nine men, who were taken prisoners to the station house. The whole was the work of a few minutes.

The sailors' procession, 1851

By a quarter to three o'clock the magistrates had returned to the police office. An immense crowd had by this time gathered round the town hall and the police office; their numbers were rapidly increasing, and low murmurs and threats began to be exchanged for loud execrations and violent acts. The alarm of the magistrates for the safety of the town was considerable, and that was greatly increased by a party of men bringing a ship's jib boom, heavily ironed at the end, and placing it opposite the station house door, soon after which they slung it, and endeavoured to use it as a battering ram, to force open the door and release the prisoners.

The magistrates now realised that they did need outside help after all. The Coast Guard was sent for:

The preventive men and coastguards were brought up by Captain Ellis with cutlasses drawn, muskets loaded and bayonets fixed, and the men from the neighbouring stations were signalled for. Captain Browne brought out his staff of East Norfolk militia, consisting of a sergeant and six men, fully armed. These latter were placed within the police office, and the coastguard men cleared the plain in front of the station.

Notwithstanding these precautionary measures, so much of excitement and irritation prevailed, that it was felt by the authorities necessary to swear in a number of special constables. Parties of coastguard men came in from Caistor, Winterton, Pakefield, Southwold etc, accompanied by their several officers. The mayor and magistrates, still apprehending that the force at their disposal would be overcome, and that property and life would be endangered, sent a telegraphic message to the commanding officer of the 11th Hussars, stationed at Norwich Barracks, stating that a serious riot had taken place, and requesting a detachment to be sent by special train. This message reached Norwich station at 4.30 p.m. Mr Martin, superintendent of the Norfolk Railway, inquired whether the case was urgent, and received an answer that the town was in a great uproar, and that the military were immediately required. The message was quickly conveyed to the barracks, and a squadron of the 11th Hussars, under the command of Capt Douglas, with Lieuts Sykes and Brisco, were soon at the railway terminus. By the strenuous exertions of Mr Martin and Mr Taylor, the station master, one troop with their horses were soon in motion, and reached Yarmouth at 6.15. The other troop followed as soon as they could possibly be despatched. When the first troop arrived at Yarmouth, Mr Martin found it necessary to clear the station; a crowd of people having assembled there, threatening to pull up the rails, and to disconnect the telegraphic communication. The Mayor, whose attendance had been requested, went to the station, and authorised Capt Douglas to proceed immediately to quell the riot. The military at once rode into the town, and having received orders, quickly cleared the streets. The rioters, frightened

at the mere appearance of the troops, flew in every direction up the numerous narrow rows peculiar to the town. In a few hours tranquillity was restored.

This report is from the *Norfolk Chronicle*, which added:

We have been assured that, but for the timely arrival of the troops a force organised in Gorleston were ready to have entered Yarmouth and made a simultaneous attack upon the town hall, gaol and the union house. It was deemed desirable to preserve order during the night, to station a strong detachment of special constables, who were relieved every four hours, and were on duty till ten o'clock on Sunday morning. During the evening several of the men who had used the battering ram were caught and lodged in the lock up.

A total of seventeen men appeared before the court on Monday charged with various offences arising out of the riot. James Knights, for whom a warrant had been issued before the riot, was sent to prison for six weeks. One of the accused, Harvey James, 'an elderly man of rather weak intellect', was discharged with a reprimand and a caution. The others were fined — and all their fines were paid by their supporters! There were two further cases on Wednesday. John Smiter, who had been apprehended since the riot, was fined £3 for his part in attempting to rescue Graystone. John Cook, one of the collectors of market tolls, accused of having canvassed the town for money to help pay the rioters' fines, was threatened with the loss of his job unless he desisted.

Five of the cases were adjourned to the following week. The accused were John Creak (twenty-eight), Benjamin Mallett (thirty-four), John Brooks (nineteen), William Bee (twenty-six), and Robert Wilgrass (nineteen). The main witness was Police Constable William Johnson. He said he had seen Mallett, Brooks and Bee in front of the station house. Mallett had had hold of the spar; Bee, a bludgeon; and Brooks, what appeared to be a handspike. Creak had struck Johnson with his fist and knocked him down, and Mallett had also struck him several times. Other witnesses told similar stories, while several witnesses for the defence claimed that Bee and Mallett had conducted themselves peaceably throughout.

The jury acquitted all five men, to the applause of the court. The Recorder told them that had they been found guilty he would have given them six months in gaol. They were then discharged.

The sailors won their case. On 14 March, the committee of the sailors' association held a triumphant — and completely peaceful — march through the town. They thanked the inhabitants for their support, which had enabled them to distribute in the previous fortnight upwards of 500 stone of flour, 600 pounds weight of beef, and 160 hundredweight of coals to families that needed

assistance. The procession started outside the Royal Exchange public house, along the South Quay, around by the Victoria Esplanade, up and across Theatre Plain, round Market Place, down Regent Street and Howard Street, and back to the place where they started. In the evening there was a display of fireworks at the Vauxhall Gardens for the benefit of the Sailors' Association.

CHAPTER 13

The 'Crime' of Selling Squeaky Dolls

In August 1895, the selling of squeaky dolls on Yarmouth beach led to a legal case of some importance. The records of the case are amongst the Town Clerk's archives at the Norfolk Record Office. On Monday 19 August, Reuben Goldfinkle appeared in the magistrates' court in the town hall. The *Norfolk Chronicle* gave the case a brief and light-hearted report, without even getting the defendant's name right:

> Reuben Goldfield *[sic]*, a young fellow who entered the court with a smiling face, appeared on a charge of hawking without a license. Police-constable Legood was on the Beach at half-past ten o'clock on Monday morning, and there saw the defendant hawking 'bladders' [actually they were dolls that squeaked]. He asked him for his license and defendant said he had not got one. When he told him that he would have to leave the beach, defendant replied that he had come down to the Races, to hawk. As he continued to do so, he was taken into custody. He now said he had forgotten to bring his certificate with him. He offered to send a 'tellygram' to London to prove whether he had a certificate or not. He had only 1s 6d in his pocket.
> (To the constable) Will 1s 6d keep me in lodging?
> Legood — I don't know what'll keep you. (Laughter)
> The Mayor — you will be remanded till tomorrow in order that you may send for your certificate.
> Defendant — Shall I send the 'tellygram' now? (Laughter)

Next morning, he came once more before the Yarmouth magistrates. The 'tellygram', sent the previous day, had brought the reply that the man's statement as to a certificate was true. The Mayor said it was the defendant's duty to carry his license with him wherever he went, in order that he might produce it whenever

called upon to do so. He had himself to thank for having been locked up, but he would now be discharged.

However, Goldfinkle was determined that 'justice', as he saw it, should be done. He took Inspector William Parker, the Yarmouth chief constable, to the County Court in Norwich, alleging a malicious prosecution. The case was held in February 1896 before a jury. 'Goldfield' now appeared under his true name, Reuben Goldfinkle, of Nottingham Place, Commercial Road, London. His solicitor was Mr Thorn Drury; Mr Poyser appeared for Parker. Drury said that on 17 August, Goldfinkle and a friend, Daniel Jacobs, had come to Yarmouth to sell squeaking dolls on the beach. On 19 August he was approached by a constable who, after some conversation, confronted him with Parker, who asked the constable what the charge was. The latter replied that Goldfinkle had acted as a pedlar without a license. Goldfinkle said that no license was required for what he was doing. In fact, although he did not say so at the time, he did have a license but had left it in London. He told Parker that he would have to take the responsibility if he charged him. Parker 'who was perhaps somewhat irritated with plaintiff for setting himself up as an authority', said that he would take that responsibility. Goldfinkle was accordingly charged with having acted as a pedlar without a license — and he was handcuffed. The judge intervened to say that no one was entitled to handcuff a person unless there was a reasonable ground of apprehending a rescue or that the arrested man was dangerous.

Drury went on to say that, as we have seen, the magistrates happened to be in session. Goldfinkle was at once taken before them and remanded until the next day. Enquiries were addressed to the police authorities in London, and when it was found that Goldfinkle did indeed have a license he was discharged.

Goldfinkle himself took the stand. He had been selling india-rubber squeaking dolls, and when the police constable had asked him if he was a licensed pedlar he had replied that he did not need a license for selling on the beach, but only if he sold door to door, but that he did, in any case, have a license. Parker said that Goldfinkle 'wanted a license for everything' and ordered the constable to put the handcuffs on him. He was taken handcuffed from the police station through the street to the police court. He was then locked up. Goldfinkle's friend, Daniel, applied that he might be bailed but this was refused.

Cross-examined by Poyser, Goldfinkle said that he knew that if he was peddling and refused to produce a license, then he could be arrested. But he was *not* peddling because he was not going from house to house. He had about seven or eight gross of the squeaking dolls, which he took all over the country. (If you do the mathematics, this works out at between 1,008 and 1,152 dolls — no wonder he was so keen to get them sold!) When at the police station, he had produced the money to pay for the telegram to London. When he was released

he bought a new license in London, as his previous one had only about five days to run. Re-examined by his own counsel, he said that everything he had on him was taken away from him before he went before the magistrates.

The only other witness was Daniel Jacobs. He said that when he heard Goldfinkle had been arrested, he went to the police station to ask what his friend had been charged with. Parker said he had been charged for hawking without a license. Jacobs also thought he knew the law and told Parker they did not need a license to sell things on the beach. Parker replied, 'You want a license and it is lucky we did not take you as well.' The pair had sold the goods on the beach and also in the town.

The question was whether the case came within the terms of the Pedlars' Act, and whether Parker had acted without reasonable and probable cause. Poyser said that a pedlar was one who, without any horse or beast, travelled and traded on foot from town to town or to other men's houses, and that any pedlar was bound to produce his license when demanded and if he refused to do so he could be taken before the justices. Drury said that before Parker charged Goldfinkle he should have found out by telegram whether Goldfinkle's claim that he had a license was true. The judge, in his summing up, told the jury that, 'as he held that plaintiff [Goldfinkle] was a pedlar, it could be required of him to produce his certificate when demanded.'

The jury found that Parker had an honest belief that Goldfinkle had committed the offence, and that it was on such grounds as would lead any cautious man in his position to belief. But the jury thought it was a matter for regret that Parker had not more time to give to the case before it went to the bench. They also regretted that Goldfinkle had been handcuffed, although Poyser now denied that this had ever occurred.

However, Goldfinkle was prepared to take the case still further, and the matter came before the High Court of Justice on 13 May 1896. It was held before the Lord High Chief Justice, and Mr Justice Wills. Drury spent a great deal of time asserting that Goldfinkle was not a pedlar under the terms of the Act, as a pedlar was defined there as one who travelled by foot, whereas Goldfinkle had travelled to Yarmouth by train! The judges did not seem to be totally convinced, the Lord Chief Justice asking, 'Is not a man trading on foot if he goes from Bury to Blackburn by train and then, when he gets to Blackburn, carries his wares on foot?' Drury also tried to distinguish between a pedlar who travelled by foot and a hawker, who travelled with a horse carrying his wares.

The main issue that they were concerned with, however, was one of malice. Had the police constable been deliberately malicious when arresting Goldfinkle or had he been making (even if Drury's case was admitted) a genuine mistake? Seeing a man selling goods on the beach — not a hawker, as he had no horse — it

was natural for him to assume the man was a pedlar, and this was a reasonable thing to assume, even if technically it was not the case. As no malice was proved, the case fell down.

Goldfinkle was the loser and had to pay costs; a great deal of time and money had been expended for nothing.

CHAPTER 14

A Day at the Races

Goldfinkle was not the only man in court that August. Yarmouth Races were held on Thursday 15 and Friday 16 August 1895. At that time, the racecourse was not on the same site as the present one but was on the South Denes, in the area around the Nelson monument, or Norfolk Pillar as it is more correctly known. The Race Course Committee had decided to crack down on criminal activities there, and an astounding variety of offences came to light.

On 16 August, twelve men were before the court charged with a wide range of offences at Great Yarmouth racecourse the previous day. The local newspaper said, 'For the most part they were a motley-looking crew, several having that indefinable appearance which stamped them as being of the horsey persuasion and frequenters of race courses.' The prosecutor on behalf of the Race Course Committee was Mr J. C. Milton.

BETTING IN A PUBLIC PLACE

First was Jack Mills, a bookmaker from London. He was charged with gaming by way of betting in a public place on the South Denes. He was asked whether he wanted the magistrates to try the case or whether he wanted to wait for the Assizes. He wanted the magistrates to deal with it, so the case proceeded. Inspector Hardesty said that he had seen the defendant on the racecourse, in a place set apart for carriages. He was standing on a box and had in front of him a bag with his name upon it, and he was betting on the field. Hardesty told Mills before the racing started that betting was not allowed there, and went to him again after the first race, pulling Mills from his box and trying his best to get him to go into the enclosure set apart for the purpose. Mills persisted and Hardesty took him into custody after the third race. Mills told Hardesty that there were plenty of other

Chief Inspector William Parker

bookmakers about — and that many of them were standing on boxes higher than his! He was searched and found to have £36 19s 1d found on him.

Mills said that if he had done anything wrong, he could not tell how sorry he was. With regard to the charge, he said had been betting in the same place for years, and his customers knew where to find him. No one could stab him in the back and say he owed them anything. He would not dispute what the officer had said, but he did not remember standing on the box during the day. If he were told that he was liable to be prosecuted because he stood there and betted with a few customers, then he would give in. He was a respectable man and worked very hard. Mills insisted that even if some betting was illegal, his was within the law.

Before giving their judgement, the bench decided to hear a similar case, that of Thomas Carlisle, another bookmaker from London. Police Constable Platten had seen him standing on a box and entering bets into a book. 'He was advised to go away but refused to do so, and commenced making use of very bad language' Platten said. Platten had taken him into custody. Carlisle asked him, 'Was I standing on a box?' When Platten replied in the affirmative, Carlisle exploded, saying, 'I was not. You never spoke to me except when you put your hands on me and locked me up. You never spoke to me once. I was "clerking" for a man. You said, "Now, give over, there's a good lad", and I said I would. I was "clerking" for a man and I get paid my wages at the end of the day. I have been ill in bed for a fortnight and this is the first job that I have had.'

The mayor, after consultation with his brother magistrates, said that as these cases were the first of the kind brought before them, the bench had decided to

fine each of the prisoners £5 and costs, or one month's imprisonment. They wished to give a clear intimation that if any others were brought before them they would be sent to prison. The case concluded with the following conversation:

Mills: 'I think if I had a solicitor the £5 would have been the other side.'
The chief constable: 'Stop talking. Your case is closed.'
The Mayor: 'Take those men away.'

Mills continued to express his dissatisfaction with the magistrates' decision, whereupon the chief constable reminded him that he was in a court of justice and not on the racecourse.

PICKING POCKETS

Next up were three men charged with attempting to pick pockets at the racecourse — William Stoakley, William Jones, and James Martins. Inspector William Dann stated that on Thursday afternoon, shortly after 3 p.m., he was on the east side of the racecourse in company with Police Constable Moore. Two ladies complained to them of having lost their purses. Not far from where they were standing they saw the prisoners in the crowd. Jones was on the right-hand side of a lady, and the other two were standing at the back of him. Jones had a coat on his left arm and his hand was down. He walked as close up to the men as he could and saw Jones' hand feeling the lady's pocket. The lady turned round, looked him in the face, apparently having felt his hand in her pocket, and then Stoakley put his foot on Jones' and all three came away. They went up the course and the witness lost sight of them for a minute. Shortly afterwards, he saw the three prisoners standing against another lady. Jones was standing on the right-hand side and the other two were at the back of him. Seeing that the men had spotted him, he left Moore to watch them. He walked down the course and met a lady named Farmer, a visitor, against whom he first saw the two prisoners standing, and she reported having lost her purse containing 19s. She had been to the police station but could not recognise the men.

The three prisoners left the crowd and went and sat down on the sand about a hundred yards off. They sat there a minute or two and then went into a drinking booth, and the witness and Moore then took them into custody. When cross-examined, Moore said that he distinctly saw the men attempt to pick ladies' pockets. He was of the opinion that they were a gang — and they did not look like novices. He was asked if he had said to the prisoners that someone had put them away (that is, had informed on them). When he denied this, all the prisoners

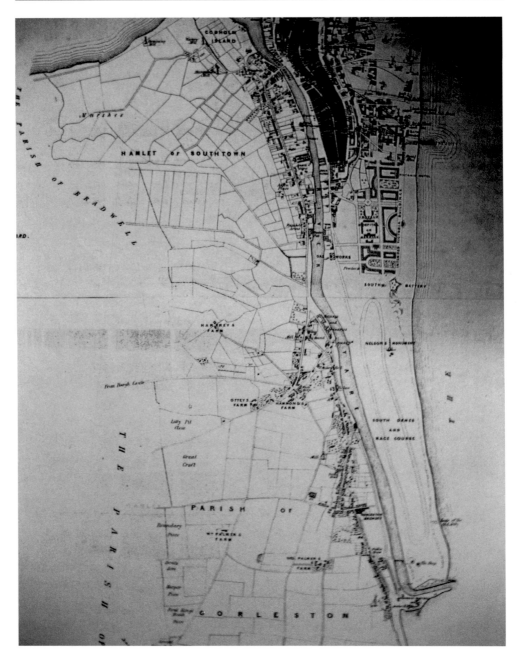

Map showing the old Yarmouth racecourse and the site of the beach murders (very close to the final 'S' in South Denes)

interrupted him, crying out, 'Yes you did'. He then said that as he was taking the men to the police station, a man whom they passed in the road had said, 'You have got the right clique there.' He had said to the prisoners, 'There is some one who seems to know you.'

The men were searched when they were arrested. Stoakley had on him just 6s 6d — and the return half of a train ticket from London. He claimed that he had never seen the others before and was a respectable race goer. He said in court that he was well known in Bethnal Green and had lived in one road there for twenty-three years. He could get a character reference showing that he had worked every day of his life. His father had three shops in London and employed sixteen men. Martins had more cash — £2 14s 3½d — and the return half of a ticket from Peterborough. He did not know the other two, he said, and in any case he had come from Peterborough, not from London. He had no occasion to pick pockets as he had a return ticket and plenty of money. Jones said he could provide references to his good character going back over the previous sixteen years. He had not known the other men. On the race course that day a man, who turned out to be Stoakley, had been standing in the crowd and had suggested a horse that was a likely winner. Jones said that he would put a bit on it, and offered to buy Stoakley a drink in return for his recommendation. It was then that they were arrested.

The accused were remanded in custody until the next Monday, so that the police could make further enquiries. When they did reappear in court, the prosecutor said that as they had been locked up since Thursday, he was prepared to drop the charges. Martins had now hired a lawyer who asked that his client's train ticket back to Peterborough be endorsed by the court, as it was now invalid! When the mayor said brusquely that the case was now closed, the lawyer said that it was not closed as far as he was concerned and threatened to bring a civil action for damages for wrongful imprisonment!

WORKING THE 'THREE CARD TRICK'

The next case was that of George Codd, accused of playing a game of chance. Inspector Hardesty said that he had noticed a number of men gathered together south of the Monument House. He and Police Constable Mason went over to them, and, just as they arrived, Codd saw them coming and took to his heels, running into the Monument House, where they arrested him. In one of his pockets they found the three cards that he produced in court.

The main prosecution witness was a local man, Robert Scales of Rackham's Passage, Albion Road. He saw Scales under the shelter of an umbrella, shuffling

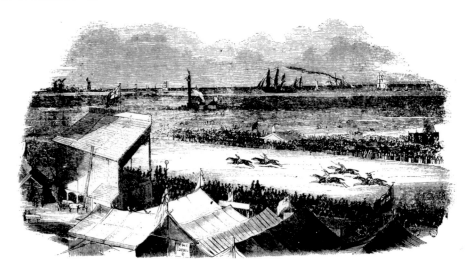

The old Yarmouth racecourse

the cards over and under and asking the bystanders to put £1 on. One man took him on, but Scales did not see who won. Police Constable Mason said that when going across the Denes a 'smacks man' shouted out that the '******' had had him for 15s. On the way to the police station, Codd threw away two cards, which a passer-by picked up and gave to Mason. Codd said that if Mason said nothing about the cards, he would 'make it right' with him. When searched, Codd had only 15s 4d on him.

Codd said that he was very sorry, but in any case he had taken no money. One man would have had a bet of half a crown but Codd could not change the sovereign that he offered. If he were given a chance he would never come to Yarmouth again. Sentenced by the mayor to fourteen days' hard labour, he asked to be fined instead, but the mayor refused to reconsider.

THE GAME OF 'JOLLYING POOL'

Robert Hunter and James Marlings were accused of playing this game on the racecourse. Detective Sergeant Lingwood said that at 4 p.m. he saw Hunter and Marlings on the South Denes with several players around them playing jollying pool. This was a game in which twelve tickets were handed round at 1s a ticket; each ticket bore a number. One man handed them out and took the money, while the other man held a box, which contained a number of tickets also bearing numbers. The person drawing the lucky number received 10s, the men keeping

2s as commission for their trouble. That sounds a simple and harmless gambling game, but there was a darker side. The men had confederates round them, and if anyone drew the lucky number their confederates were bound to have one or two also so that the stake would be divided.

Lingwood was presumably in plain clothes, as he watched them playing until a policeman came in sight, when one of the men called out 'Age' and both made off. (This is how it was reported in the press, perhaps he really called out 'Agee', which is a warning shout men make to horses to move aside.)

Lingwood chased and caught the two men, who naturally struggled — luckily, help arrived and both men were arrested. Hunter had £2 15s 2d and a return ticket to Leicester on him. Marlings had 9s 0½d. Both men pleaded for mercy. Marlings said it was the first time he had been before a court, he had worked for many years in a lace manufactory but had had no work for some time, and he had a widowed mother totally unprovided for. Hunter also said it was the first time he had been in court or locked up. He had a wife and child, and if he were sent to prison he did not know how they would be supported. He hoped he would be fined. He would do any mortal thing — 'even to labouring' — rather than offend again.

The judge sentenced the two men to fourteen days' hard labour.

TICKET SNATCHING

The accused was John Jones. The prosecution said that he believed that the procedure was as follows. Men like the prisoner frequented racecourses, and ascertained as near as possible who in the crowd had winning tickets. Then, by some device, such as shouting out, they snatched the tickets from them.

Police Constable Smith said that he was on the racecourse and actually saw Jones snatch a ticket from a man named Bensley. He passed it at once to another man who was in the crowd, but Smith could not get through the crowd to get at him. Bensley caught hold of Jones and held him until Smith came back and arrested him.

The victim was, naturally, the main witness. He was Jesse Bensley of Barrack Street in Norwich. He had 'done' certain horses during the afternoon, and had got the winner in the last race. He had lost all the others through welshers (these people are described later). When he went to take his money, 'this gentleman [Jones]' who had a little bag in his hand, had shouted out, 'Pay out here'. Bensley hesitated, as Jones was not the man to whom he had originally given his money. When Bensley held up his hand with the ticket in it to the man with whom he had actually made the bet, Jones snatched it out of his hand. He immediately put his

Building the present Yarmouth racecourse: materials from the old one were moved across the town.

hand behind his back and passed the ticket to another man. Bensley caught hold of Jones and held him until the police came. His hat came off — perhaps knocked off his head by Jones — but rather than lose hold of Jones, he lost it.

Jones said that there was a bookmaker on the course with a framed portrait in front of him, and he was just standing in front of it to protect it. The man with whom Bensley had taken the bet took the ticket and threw it away. In mitigation, he said that he had been in an asylum for eight weeks and had only been out for a month. He too was sentenced to fourteen days' hard labour.

DRUGS IN THE BEER

The last case of that day was that of William Stone, who was described as a horsey-looking individual (presumably meaning that he looked the kind of man who went to race meetings rather than that he actually resembled a horse!) He was charged with being drunk and incapable. He was found by a police constable lying drunk on Regent Road, while an 'unfortunate' was 'trying to get him away' — that is, to steal from him. When searched at the station, he was found to have a

large sum of money, over £8, on him, so he had presumably been lucky in his bets. It was just as well for him that he had been arrested before he was robbed. Stone said in court that he thought someone must have drugged his beer, with a view to robbing him, and agreed with the magistrates that it was a fortunate thing that he had got into the hands of the police. He was fined 10s and costs.

The cases continued on the following day, this time with Mr H. Chamberlin as prosecutor. He began by saying that he hoped the magistrates would assist the Race Course Committee in keeping the races respectable and clearing the course of all bad characters. Six more racing men were up before the court, charged with offences at Friday's race meeting.

STEALING A VALUABLE COAT

Philip Watson and William Hackle were charged with stealing a 'dust overcoat' worth £5 from a carriage on the South Denes. George Herbert Francis, a medical man from London, was staying at Mettingham and had come over to Yarmouth for the races in a wagonette, which he left on the east side of the course. During a race, he heard a shout, 'That coat's gone.' He looked around and saw Inspector Dann with his coat, and he did not see it actually being taken. The coat, which was a long waterproof, had cost him £6 6s two months previously.

Inspector Dann said that he had seen Watson and Hackle among the crowd and watched them for about half an hour. Just before the start of a race, Watson leaned on the wagonette, with Hackle standing beside him. Someone called out, 'They're coming!', meaning the horses, and the occupants of the wagonette stood up. Watson reached in, grabbed the coat and passed it to Hackle who ran away — straight into the arms of Dann!

Caught in the act, Watson and Hackle both had little option but to plead 'guilty' and throw themselves onto the mercy of the court. Watson said that he was half drunk at the time and asked that a small fine be imposed. Hackle said that he had a wife and family. Both men were sentenced to two months' hard labour.

WELSHING

Thomas Sharp was charged with stealing, by means of a trick, 25s from Arthur Morrell. Morrell was a surveyor staying at Bungay, who came over to Yarmouth for the races. He saw Sharp acting as a bookmaker with another man in the half crown ring. Morrell put 5s on a horse called Sir Jacob at four to one. Sharp put

the bet down in a book, while his associate took the money, and he gave him a ticket marked with the bookie's name, Fred Gordon. Morrell went to watch the race, the Norfolk and Suffolk handicap. He was in luck (as he thought): Sir Jacob won. He went back to where he had seen Sharp, but the bookmaker and his man had *welshed*, that is fled rather than pay out. There were forty or fifty other people there, some with winning tickets. They smashed up the property that Sharp had left behind him but Morrell was not satisfied with that. On the next day he went to the racecourse in company with Detective Sergeant Lingwood. Sharp was there again, taking bets — but under a different name.

Lingwood said that Sharp was bookmaking and using tickets that had on them the name 'Watson Bros, London'. Lingwood showed him Morrell's ticket and said that Sharp had done him for 25s. Sharp tried to put them off, telling them to wait till after the races, but he and Lingwood eventually went round about a dozen of the bookmakers there trying to borrow a sovereign from them, but none of them would give him a loan. Lingwood then charged Sharp with stealing the money. On being searched, Sharp had only 3s 8½d on him, and no return ticket.

Sharp said that had Morrell come half an hour earlier, he would have been able to pay him, as he had plenty of money then. He told the bench that his name was not Gordon, and that having won £8 12s, he had joined Watson on the second day, only to lose it all. He added that, 'Not one man in fifty used his right name on the cards.'

Inspector Record of the Metropolitan Police came to the court saying he had known Sharp for fifteen or twenty years. He was a frequenter of racecourses and an associate of dangerous characters. Unless he gave long odds no one would bet with him, because his appearance was against him. Sharp was sentenced to one month's hard labour.

A SUSPECTED GANG OF THIEVES

William Smith was charged with stealing a gold pin worth £3 from Charles Wilde. Wilde had gone to the races wearing a gold and pearl pin in his scarf. He felt a tug at his scarf, and, turning, he saw Smith standing close to him. He at once accused him of the theft. Smith said nothing but walked away and then broke into a run.

Police Constable Platten said that he was in the half-crown ring when he heard someone calling 'Police!' He saw Smith running away, so he chased him and caught him. Wilde came up and said Smith had stolen his pin. Lingwood arrived and said, 'Why don't you give the man his pin?' Smith replied, 'You have made a mistake.' Platten took him to the police station, where he was found to have

three playing cards, an imitation ten-pound note, and 4s 6d in cash — but no pin. When charged at the station, Smith made no reply.

Lingwood said that he also had chased after Smith and had seen him put his hand behind his back: another man, who was immediately to his rear, then ran off. Lingwood seized Smith's wrist and asked him to give up the pin, but Smith said that he had not got it. Lingwood believed that Smith had passed the pin to his partner in crime, and it had not been recovered.

The Chairman of the magistrates said that, although his conduct was very suspicious, there was not sufficient evidence to convict Smith. He was therefore acquitted.

OUTSIDE BETTING

Two more men, Frank Chandler and Harry Thomas, were charged with illegal betting. Police Constable Herring said that he was outside the carriage enclosure on the South Denes and saw the two men sitting in a wagonette. When the numbers were hoisted for the first race, Chandler received several sums of money from different people. Thomas entered the bets on a card. After the race, those who had won went to the men and their winnings were handed to them. The same thing happened in the second race. At the third race, the police took action. Seeing Chandler accept a coin — a florin or half-crown — he and a police sergeant arrested the two men. Thomas had a box beside him; the box contained a book, several betting tickets and a leather satchel. They were taken to the police station and searched. Thomas had two race cards, two railway tickets, a number of papers, and 4s in silver. Chandler had £1 9s 1d, and several betting tickets, which bore the name 'Frank Chandler, London'. Both men denied that they were betting, but the police sergeant said that he too had seen them in the act of taking bets. They were both punished with either a 40s fine and costs or one month's imprisonment.

CHAPTER 15

On the Beach: Nights of Fear

Yarmouth has many miles of beach — one of its great attractions to holidaymakers. The area between the Britannia Pier and the Wellington Pier was developed first, but by about 1900, the development was spreading further south beyond the Wellington, and towards the racecourse and Nelson's monument. The beach on a summer's daytime was crowded and safe, apart from the occasional pickpocket and snatch-thief. It was very different at night, 'in that hour of darkness', as Sherlock Holmes says, 'when the power of evil is exalted.' There were predators on the lonelier parts of the beach then, north and south of the safe area between the piers, men after more than handbags, and not above murder if their aims were frustrated. The next three cases are all of this kind. In the first case, the woman had a fortunate escape, and in the other two the result was death.

The first case involved Catherine Brett. She was a visitor from London, staying with her husband, William, and their baby at 24 Wellesley Road. One Thursday night in August 1899, at about 11.15 p.m., the young couple went down to the beach north of the Britannia Pier. Their object: to get some salt water in which to bathe their baby. Catherine took off her shoes and stockings and went down to paddle in the water, followed by her husband. She came ashore first; while she was alone on the beach, a man came out of the darkness and grabbed her by the neck and tore at her clothing. There was a struggle and, naturally, she screamed. William heard her and ran to her, seizing the man, who proved stronger than him, knocking him down three times. Eventually Brett got hold of the collar of the man's coat, but the man squirmed his way out of the coat and ran off — straight into the sea. Brett chased after him but, as it appeared to him in the darkness, he swam away. He went onto the Parade and called out for the police.

Christopher Symonds was a stoker at the Electric Light Works. His shift finished at eleven and he was walking home when he heard shouts and shrieks. He ran to where Brett was standing on the Beach Wall. Brett told him what had

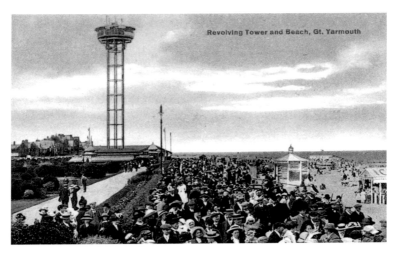

Revolving Tower and Beach, Gt. Yarmouth

The beach north of Britannia Pier

happened and Symonds went to the edge of the water. Peering into the darkness, he saw an arm turn over in the foam, as if a man was rolling around in the sea. Two other men had turned up by this time, and they pulled the man out and laid him out on the beach. Symonds thought that the man was still alive. This was only 50 yards north of the Britannia Pier.

Police Constable Johnson was on duty near the Bath Hotel. He got to the scene five minutes after midnight and saw the man lying on the beach. He decided to rush him to Yarmouth Hospital. At the inquest, the coroner said he would have done better to get a doctor to come to the beach, but a medical man would have been hard to find at such a late hour. The man arrived at the hospital just before 1 a.m., with foam coming out of his mouth. A doctor tried artificial respiration but it was too late: the man had died. According to the doctor, he smelled strongly of alcohol, although Brett said that he had not noticed this. Johnson searched his costume; the only thing in his pockets was a piece of soap. His hat, which had come off in his struggle on the beach, had the pencilled letters 'H. G.' on the inner lining.

The inquest was adjourned until 4 September in the hope that the man's identity could be established, but to no avail. The chief constable said that photographs of the dead man had been sent out to 212 towns in the United Kingdom, but with no result.

At the adjourned inquest, the Bretts' landlady gave evidence. The couple had booked in for a fortnight, and the incident had happened on the tenth day of their visit. It was Mr Brett's habit to go down to the sea late in the evening with a galvanised can to fetch some seawater in which to bathe the baby the following

morning. This particular evening was unusual only in that Catherine had gone to the beach with him.

The coroner said that the unidentified man had undoubtedly drowned. The question was whether he was trying to escape or whether he was intending to commit suicide. If the jury were unsure, they could return an open verdict. They were sure, and their verdict was 'accidentally drowned'. In their view he had entered the water in an attempt to escape capture.

The assailant never said a word to Catherine or William Brett, and to this day he has never been identified.

CHAPTER 16

'The Stark and Stiff Corpse of a Woman': the Yarmouth Beach Murder

The Yarmouth beach murder of 1900 was a sensation. It filled the local newspapers for months, so much so that it was thought the accused could not have a fair trial in Norwich, and the case had to be removed to the Old Bailey. It is also a case where a probably innocent man was hanged.

The drama began at 6 a.m. on Sunday 23 September. A fourteen-year-old local boy, John Norton of 36 Boreham Road, went down to the beach for a swim before going to his place of work, the bathing huts on the beach. He crossed the Marine Parade and in the sand hills at the edge of it, just opposite the Barrack road opening, he came upon what the *Eastern Daily Press* reporter called 'the stark and stiff corpse of a woman' (The reporter obviously liked this phrase as he used it again in his account of the inquest five weeks later). He fetched a policeman, Police Constable Manship, who was there within half an hour of the first discovery of the body. Manship saw that the woman was lying on her side, with her hands by her side — and footmarks in the sand around. He lifted the body and beneath her found her white pocket-handkerchief. Beside her was her white straw hat. She looked to be about thirty years old and five feet two inches tall. Her face was scratched, and there was a mohair bootlace knotted tightly around her neck, cutting into her skin. She had on a wedding ring, and several rings on other fingers. Manship sent Norton to fetch a William Wood of 60 Ordnance Road, who had a cart on which the body could be removed.

That afternoon she was identified — or so it was thought. Mr and Mrs Rudrum of house No 3, Row 104, recognised her as a visitor who was staying with them. She had told them that her name was Mrs Hood, that she was from Yorkshire, a widow, twenty-seven years old, and that she had recently spent four months in South Africa. With her she brought her child, who she said was called Rose and was one year and eleven months old. When the police searched her possessions that day, they found a cheap beach photograph of her and her child on the beach

— and the return half of a London/Yarmouth train ticket, so already some doubt was cast on the truth of her story.

The inquest was opened at the town hall on 27 September, the jurors going across the road to view the body in the mortuary and then returning to the hall to hear the witnesses, starting with the Rudrums. John, who was a shoemaker, said that Mrs Hood had been lodging with them since 15 September. On the very first night of her stay, she had gone out and not returned until midnight. He was looking out for her and, when she eventually turned into the Row, he noticed that there was a man with her. However, he could give no description of the man. One letter had come to her during her stay, and his family had more to say about the letter. Eliza, his wife, said that it was in a blue envelope and was addressed to Mrs Hood, and Alice, his daughter, said that it had a Woolwich postmark. Mrs Hood had read part of the letter aloud to them, 'Meet me at the big clock at 9 o'clock, and put your babe to bed.' Alice had also seen Mrs Hood on both of what were to be the last two nights of her life. On Friday 21 September, she had seen Mrs Hood from her window coming back to the house at about 10.50 p.m. She was with a man, and she heard him say to her, 'You understand I'm placed in an awkward position just now.' He kissed her, wished her goodnight, and walked away. On the Saturday night, she had seen Mrs Hood waiting outside the town hall (the very building in which the inquest on her body was now being conducted) just before nine.

The funeral was held at Yarmouth cemetery the following day, attended by the Rudrums and about twenty curious spectators. The coffin plate bore the words 'Unknown woman (Hood)'. The inquest was continued after the funeral. Manship told what he had found, adding one important detail: the knot in the bootlace was a reefer knot, a kind only common among sailors. Manship had been at sea for ten years before becoming a policeman, so he knew what he was talking about. The coroner was unhappy with him, saying that he was wrong to have removed the body and should have guarded it while the chief constable was fetched. Medical evidence confirmed that she had died from being strangled; she had not been sexually assaulted.

It was now revealed that the woman's clothes bore the number of 599, probably a laundry mark and something the police, naturally, followed up. The inquest was adjourned until 29 October, but as the murder victim had still not been identified, the verdict had to be on an unknown woman. Inevitably, it was 'wilful murder by some person unknown'.

The next step in the drama was just over a week later. The *Eastern Daily Press* of 8 November announced that a man had been arrested in connection with the murder. He had been arrested in Woolwich. Now, at last, the true names came out. The victim was Mary Jane Bennett and the arrested man was her husband, Herbert John Bennett.

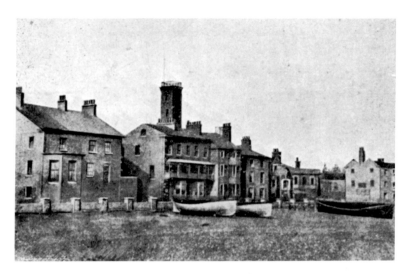

South Beach, location of the two beach murders

How had the police tracked him down? Chief Constable Parker had kept the case in his control as long as he could, but even before the final session of the inquest he had realised that he needed to call in Scotland Yard. Although portrayed as bunglers in the Sherlock Holmes stories, they had the ability to do a great deal of plodding research work. They had two clues to work with:

1.) THE LAUNDRY MARK
This was made by many laundries throughout Britain, and they were all investigated. Among them was one laundry in Bexley Heath, where a recent customer's name was Mrs Bennett. This fact was noted, along with results from all the other laundries.

2.) THE MENTION OF SOUTH AFRICA
Police looked at passenger lists of ships to and from South Africa for people named Hood — and there were a good many — and interviewed steamship company employees. One employee, Walter Penton, remembered one of the couples named Hood on a recent voyage from South Africa. He said that he had noticed an old torn label on Mr Hood's portmanteau — on it was written the name 'Bennett'. They also found a man who had sold tickets to a couple named Hood for the outward journey a month before. He was Henry Finch, and he had records of the numbers of the banknotes with which he was paid. They were traced back and found to have been withdrawn from the Woolwich branch of Lloyd's bank. The name of the person who withdrew them? Bennett.

A typical bathing machine. Men's swimming costumes had to hide the body from neck to knee!

Scotland Yard noticed how often this name was cropping up and made further enquiries into the woman who was Bexley Heath laundry's 599. The laundry owner was shown the beach photograph and immediately recognised the woman as his customer, Mrs Mary Bennett. It was soon established that she had been missing since mid-September. The obvious suspect was her estranged husband, Herbert Bennett, who worked at Woolwich Arsenal. The links were complete and, apparently to his complete surprise, Bennett was arrested as he left work. He was never to know freedom again.

Whole books have been written about the Bennetts but their history can only be given very briefly here. Herbert was only twenty-one at the time of the crime, Mary being slightly older at twenty-three. They had met when Herbert became one of Mary's music pupils. They married at Leytonstone on 22 July 1897. Mary was pregnant at that time, giving birth in November, but the child was stillborn. The couple later had a daughter, Ruby, who was born in October 1898, and this was the child Mary had brought to Yarmouth. The couple had indeed recently gone to South Africa, perhaps to escape their creditors. They booked tickets, as we have seen, under the name of Hood. They left Ruby with Herbert's stepmother, whom they told they were going to America!

In the end, they were only in South Africa for four days (not the four months Mary had mentioned to the Rudrums). They arrived back in Southampton on 9 May 1900.

Mary Jane Bennett

The couple separated soon after their return, with Herbert visiting his wife and daughter (whom Mary had reclaimed) once a week. He soon found another girlfriend. He first met Alice Meadows on 1 July. They spent a weekend in Yarmouth together between 4-6 August, staying at the Crown and Anchor on Hall Quay — in separate rooms! They also spent a fortnight in Ireland in late August and early September. They were engaged to be married and had just begun living together in a house in Charlton — naturally, Alice had no idea that her intended already had a legal wife. Just two days before the arrest, the conversation had turned to the murder in Yarmouth, and Herbert is said to have shown no interest in the matter!

Bennett's house was, of course, searched. A silver watch and gold chain belonging to Mrs Bennett were found. These were later to take on a key role in the trial, as it was claimed that Mary was actually wearing these at the time of her murder. A receipt was also found from the Crown and Anchor, dated 4 August, some collars with the now-familiar laundry mark of 599, also a man and a woman's wig — and a false moustache!

Committal proceedings opened at Yarmouth Town Hall on 9 November and, on 1 December, Bennett was sent to the assizes for trial. The proper place for this was Norwich, and Bennett was held in Norwich prison. However, because of the activities of the newspapers, many people felt he would not get a fair trial in Norfolk. His trial was transferred to the Old Bailey in London on 23 February 1901. Bennett was defended by Marshall Hall.

The evidence was contradictory, one witness being sure that Bennett was in Yarmouth on the night of the murder while one was equally sure that he was in London. Three men whose evidence was far from conclusive can be taken first. Edward Goodrum, the boots at the Crown and Anchor, claimed that Bennett came to the hotel at about 11.45 p.m. on the Saturday, but he did not recognise him as having been at the hotel six weeks earlier. Walter Reade, at the time a waiter in the hotel, also thought the man was Bennett. Both men said he had arrived out of breath, which he explained by saying he had missed the last train from Gorleston and had had to run. However, Reade had identified Bennett at a most unsatisfactory identity parade at the police station — he already knew two of the men in the parade, and the other two were nothing like Bennett! The man left the hotel early on the following morning, Sunday. J. W. Headley, a newsagent, had gone to the station to collect his papers early on that Sunday morning. He saw a man, probably the one who had just left the Crown and Anchor. Was he Bennett? He was only prepared to say that he was very much like the prisoner, saying, 'I honestly believe it is, but I do not like to swear positively to him.'

However, there was a witness who *was* positive he had seen Bennett in Yarmouth on that Saturday night — and in company with Mary Bennett! This

The Bennett case. Scenes in court

was William Borking, landlord of the Mariner's Compass on the South Quay. Portly, and with a large beard, he was treated as a figure of fun by the court and even by the judge. He said firmly that the couple had come into his bar between 9.30 and 10 p.m. on the evening of the murder. He said that Bennett had on a blue shirt-front 'just like mine'. The judge looked at him, with his large beard, and said, 'I don't see any front', which caused laughter in the court. Borking said that the man ordered 'two Johnnie Walkers'. The judge misheard or pretended he had. 'What, gin and water?'. 'No, Johnnie Walkers,' repeated Borking, as the court again erupted in laughter. He remembered that Bennett had twirled his moustache, which Hall ridiculed: you could not twirl the thin moustache that Bennett had. 'He has not a heavy moustache,' Hall said, 'he is only twenty-one or twenty-two.' The heavily-bearded Borking retorted that he himself had had a bigger moustache before he was twenty-one. 'Perhaps you had it before you were born?' suggested Hall facetiously. 'I don't think I had', Borking replied, and this exchange produced further gales of laughter in court.

However, his washerwoman, Elizabeth Gibson, was also sure that the man in the pub that evening was the prisoner, but that he had a heavier moustache than

he now wore. Borking was not an unbiased witness. He had saved the glasses from which he claimed the Bennetts were drinking, presumably to make money out of them. He had also had himself and his bar photographed by the press. In his defence speech, Hall was worried that the jury might think Bennett had been wearing the false moustache that had been found in his house, and he squashed this idea by saying that the false moustache could not be worn over a real one, such as Bennett undoubtedly had.

Despite the jokes, this was solid evidence against Bennett. However, another strong witness was sure Bennett was not in Yarmouth but in South London. This was Douglas Sholto Douglas of Lee Green, a maker of fancy boxes. He gave evidence that he had seen Bennett on 22 September and he could prove the date. Normally he potted plants every Saturday but on that day he had gone out for a long walk instead. He always put dates on his pots, and hence he had plant pots with the dates 15 and 29 September, but none for 22 September!

His long walk took him to Eltham. He was there about four in the afternoon and began to walk homewards along the Eltham Road. He was overtaken by a man whom he had never seen before, but who asked him for a light. He now knew that this man was Bennett. As they were going the same way, they naturally walked on together. Bennett commented that the days were growing short. Douglas said this was to be expected as they were just one week short of Quarter-Day — 29 September. The two walked together to the Tiger Inn and Douglas took Bennett in for a drink. As they came out, the man saw a shop sign next to the pub and said, 'A namesake of mine apparently lives there'. The sign read: 'F. K. Bennett, shaving saloon'. There was a bus close by as the men parted company, and Douglas heard the conductor say that it was 7 p.m.

Douglas could not be shaken, claiming, 'I had no doubt that the prisoner was the man I met in the lane on 22 September... I have not a shadow of doubt about the man or the date.'

It is *impossible* for a man to be in South London at 7 p.m. and in Yarmouth two and a half hours later. One of these two witnesses was either deceived or was lying — but which?

Hall had two further lines of defence, one so ridiculous that it probably weakened his case in the minds of the jurors. This was that of Mr J. H. O'Driscoll, a Lowestoft stationer. He said in court that at 9 p.m. on Wednesday 26 September, three days after the murder, a man had come into his shop with scratches on his face. He asked for a paper with a report of the murder and read it in an agitated fashion. Looking at him curiously, O'Driscoll noticed something odd: there was a bootlace missing from one of his shoes! The man ran out of the shop when he saw O'Driscoll staring at him. Apart from the innate ridiculousness of the idea that a man who strangled a woman with a bootlace on a Saturday night would still be walking about in

boots without a lace three days later, the prosecutor was able to produce evidence that further weakened the story. Although it might have been expected that Mary would have struggled and that her attacker would be scratched, in fact the medical evidence was that there was no skin on, or under, the nails of the dead woman. It was, however, possible that this could have been forced out as she clutched the sand in her dying agony, so that the evidence was not decisive.

Hall's other line of defence was probably the most important but he did not seem to been able to get it into the minds of the jurors. There was one tangible link between Bennett and the murder: the watch and chain. Everyone seemed to be assuming that the watch and chain worn by Mary on the night that she was murdered were the same as those that had been found among Bennett's things after he was arrested. Damning evidence indeed — but was it true? Hall produced a witness to say that it was not — Mrs Susan Cato of Tooting, a friend of Mary's. Mrs Cato was sure that Mary had two chains and two watches. One of the chains was real gold, the other an imitation she had bought when she had been forced to pawn the valuable one. As for the two watches, sometimes she had both on at the same time, and she had been in the habit of letting her baby play with them, so that they both had teeth marks.

If this was true, the one fact definitely linking Bennett with the crime was gone. The prosecutor Charles Gill was anxious to pooh-pooh Susan Cato's story and was able to make her admit that she had not told the police anything about the two chains at the time, but she claimed that this was because she was not asked about them! He returned to the matter in his closing speech saying firmly: 'The identity of the watch and chain as the dead woman's, and their possession by the prisoner are matters proved beyond doubt.' This must have left the jury with the impression that Bennett was indeed caught in possession of the watch and chain that Mary was wearing at the time of her murder.

On 2 March, the trial finally came to its end. The jurors were out for only thirty-five minutes before they gave their verdict — 'guilty'. Asked if he had anything to say, Bennett said simply, 'I say I am not guilty, sir.' He was sentenced to death and was returned to Norwich Prison. There was no Court of Appeal at this date, so Marshall Hall appealed directly to the Home Secretary for the sentence to be reduced to one of imprisonment. This fell on deaf ears, and on 21 May 1901, Herbert John Bennett was hung at Norwich Prison. Hangings were by this date conducted in private, but a crowd always gathered outside the gaol. When the large black flag customarily flown at the time of an execution was being raised, the flagpole snapped; many of the people watching saw this as a sign that an innocent man was being hanged.

Marshall Hall thought in later life that Bennett was a born criminal and deserved to be hung — but that he was innocent of this particular crime and that

he did not murder his wife on Yarmouth Beach on 22 September 1900. However, he obviously did not think much of the evidence of Sholto Douglas. His theory was that Bennett was indeed in Yarmouth that night, and did meet his wife earlier in the evening. After he had left her, Hall thought, she had met another man — and was killed by him on the beach when she tried to resist his sexual advances.

CHAPTER 17

'A Dark Mystery': the Second Beach Murder

In 1912, the body of another young girl was found on almost the same spot on the South Beach. She too had been strangled with a shoelace. Naturally, the local newspapers had plenty to say:

Yesterday morning the body of a young woman, who had been the victim of a horrible death, was discovered on the South Beach at Yarmouth, and now lies at the local mortuary. She had been foully murdered, and the manner in which she had been done to death — it must have been about Sunday midnight — closely resembles the crime of twelve years ago for which Bennett paid the penalty on the scaffold at Norwich. In each case the victims were women, and each of them was found strangled. Bennett, it will be remembered, used a bootlace to kill a woman of whom he was tired.

In the present instance not only were a pair of stockings tied around the woman's neck, but over these had been used the laces from her shoes. She was found shortly before five o'clock yesterday morning (ie 14 July), and the medical opinion is that life had been extinct for five or six hours. The murdered woman was about 5 ft 4 ins high, with light brown eyes and dark brown hair. She was well built. One of her centre teeth is partly decayed away, and she appeared to be about from eighteen to twenty years of age. She was wearing a blue serge dress of modest make, with a hat of more pretentious style. Her underclothing is of moderate quality, and her pocket was practically empty, her circumstances being indicated by the fact that she had in her possession a small fancy handkerchief, but it was darned.

Yesterday morning all the deceased woman's clothing was identified by one of her aunts, who later viewed the body. Deceased was Dora May Gray, aged between 16 and 17, whose home was at the back of a terrace of houses on Manby Road, Yarmouth. She had neither father nor mother, and had been brought up by her aunt, and had a situation as day girl. As far as can be at present ascertained, she was last

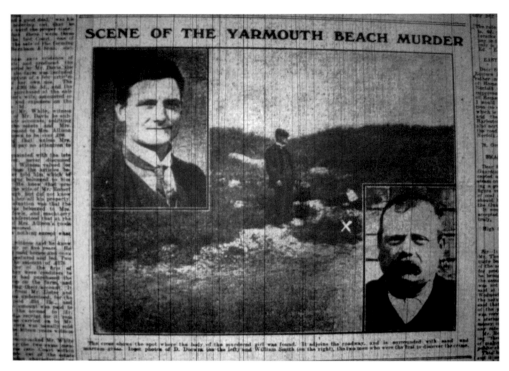

Dora Gray: the murder scene, from a contemporary newspaper

seen alive on Sunday night at about eight o'clock in the vicinity of her home. The gap that has now to be filled in by the police is to trace her movements for the four hours between that time and midnight, when she met her death.

From a neighbour we learn that the deceased was a tall, lady-like girl, who appeared to be at least eighteen, who had a situation close to her own home. She was seen by the neighbours to go out on Sunday evening and was then quite alone.

It is anticipated that the Inquest will open today, the Coroner having been anxious that the police should have had time to make some investigations into this mysterious crime, which has thrilled and startled the thousands of visitors who are accustomed to find in Yarmouth Beach such a happy holiday ground. The motive for the crime opens up so wide a field for conjecture that it would be unprofitable to speculate upon the circumstances of this poor girl's sad fate.

This article was immediately followed on the page by another one giving the latest developments — the early-twentieth-century equivalent of a rolling news programme?

The discovery was made, as we have said, shortly before five in the morning by a couple of men who had gone to the South Beach with a horse and cart. On the sands between the sea and the scenic Railway they were horrified to observe the extended form of a woman, who was lying not exactly towards the sea but in a SE position. Her tongue was protruding, and her feet and legs bare, while around her neck were some tightly fastened wrappings. One man was left with the body whilst a message was taken to the Police-station. The Chief Constable, who was immediately communicated with, went to the scene of the tragedy in a motor cab, and Dr Thomas Lettis, the police surgeon, quickly followed. The body not having been disturbed in any way, a thorough preliminary examination was made. What at once attracted attention was that there were no signs of a struggle, so that the woman could hardly have made any resistance to her assailant. There were no tracks of any vehicle, other than the cart, to be seen on the spot. The deceased's hair was secured at the back with two ribbon bows, one at the top and the other at her neck. He feet were examined to see if it were likely that she had been paddling in the sea prior to her death, but as they still bore the impression of the ribs of her stockings, she had clearly not been in the water so recently as a few hours before death. This external examination having been made, the body was despatched to the Mortuary in a motor car, rather than wait for the arrival of the mortuary car, and before the public began to stream to the beach all signs of the midnight tragedy had vanished from the scene.

For the benefit of those who may not know the position of the Scenic Railway at Yarmouth, although it has been the resort of thousands and tens of thousands during the last three years, it may be stated that it lies immediately beyond the furthest Beach Gardens, known as the Nelson Gardens, to the south of Wellington Pier, whence the Beach stretches away to the harbour's mouth. The scene of the crime is not far from the well-known Nelson's Column, but on the sea side of the Marine Parade. The Chief Constable had the detective squad out immediately he was made aware of the finding of the body, and the passengers by the morning trains from Yarmouth were scrutinised with a view of noting any suspects, but at present there are no clues, and the police have a big problem on hand to solve to bring home the crime. Hitherto the Yarmouth police have not been unsuccessful when faced with mysteries of this character; and everyone will hope that their efforts may lead to a direct result. No arrangements have yet been made for the inquest.

So far as inquiries go nothing was heard on the South Beach or in the vicinity at night or towards midnight to attract attention. No sounds of quarrelling were overheard; and it is not unusual in Yarmouth for people to be walking about up to midnight and in the small hours of the morning, especially during a heat wave. The presence of a couple of persons on the Beach even beyond the Parade would not in the ordinary way attract attention, and in that way the victim and her assailant

probably eluded the notice of everyone. The method in which the stockings and laces were tightly knotted round the woman's neck suggests that deceased must have been completely overpowered at the time the attack was made upon her. While it is possible to put forward the theory that she was first brought under the influence of drink, her appearance does not suggest that she was addicted to drink. The news of the tragedy leaked out after breakfast, and caused the greatest sensation in the town.

It appears that the neck of the deceased had not been very deeply penetrated by her shoe lace, which was tied with a reefer knot and passed twice round. This occupied a position on the throat higher than the stockings. One stocking was secured twice around her neck, and the other once. These were apparently pulled off in haste, as they were turned outside in. Deceased's hair has been found to be plaited to the extent of its full length, with a bow at the top and another at the bottom. Her eyes are light brown, and the deceased has very heavy dark brown eyebrows, nearly meeting on her forehead. Her hat of brown and rather faded straw has a broad band of pink ribbon, and in front is trimmed with two large pink roses. In this hat was found what appeared to be a sort of mob cap, which can be drawn up by strings, and upon this written in ink has been found the word 'Laranas'. Sometimes girls have a cap of this kind in their hats to make them fit more comfortably, or as an easy and convenient mode of carrying a small part of their wardrobe. With this mob cap there was also a double-fronted flannelette collar. That these things had been in her hat some time is shown by the number of holes in them where they had been pierced by hatpins.

The two men who discovered the body were William Smith and David Docwra, who were driving two or three hundred yards south of the Nelson Monument on the east side of the road, when they saw the body not more than six feet from the edge of the road — a remarkable circumstance that suggests a dim possibility that the body might have been brought there after death. Smith and Docwra drove back upon the Parade till they met Sergeant Herring near the *Holkham Hotel*. They drove him back to the scene of the crime, and he was left beside the body while the men drove up to the Police-station to report their terrible find. No time was, therefore, lost in the police setting to work.

We understand that there is no theory of outrage precedent to the murder entertained by the police at present. Inquiry is being made in every likely quarter to elicit information, so far there has been no arrest.

The same edition of the newspaper (Tuesday 16 July 1912) contained a photo of the crime scene, and the two men who found the body — this is the only photo in the whole paper.

The inquest opened on 16 August, and once again it was held at the town hall. The coroner said that Dora lived at the back of 10 Manby Road with her aunt Miss Selina Eastick, who herself lived with her sister Mrs Harriet Brook, a

widow. Selina said that Dora had left the house at about 7.40 p.m., saying that she was going for a walk and would not be late. The two carters found the body at about 5 a.m. on the following morning. Docwra had stayed with the body, while Smith went to find an officer, coming across Herring and bringing him to the scene. The jury then walked to the Mortuary and viewed the body.

Selina formally identified the deceased, and said that Dora had worked for Mrs Newman of 2 Manby Road. She was eighteen and had been living with Selina since her mother deserted her when she was nine months old. It had been her custom to go out each Sunday evening. Normally she came back about ten, and when, on this occasion, she did not return, the two women sat up all night waiting. Selina was in the Market Place at about 8.30 on Monday morning when she heard that that the body of a young woman had been found on the beach. In the afternoon she went to the police station, where she was shown clothes and shoes, which she recognised at once. She was then shown the body itself, which she identified. Examined, she said that she did not know if Dora's mother was alive or not, she had gone to Peterborough and Selina had not seen her since. She had never seen Dora with a man, and did not think she had an attachment. She had never been out later than 10 p.m. before. She had worked for Mrs Newman all winter, and was only home because it was Sunday. She did not do the housework at Mrs Newman's but minded a baby there.

The Deputy Borough Surveyor produced a map to show exactly where the body was found, six feet to the east of the Marine Parade, 292 yards south of the centre of the road leading to Nelson's Monument.

Smith was a carter of 9 Fullers Hill. He said that he and Docwra were breaking in a young horse. It was Docwra who saw the body first, in the marram grass. Neither of them had got down, but they had driven on and found Herring, taking him back to the spot. Asked about the body, he said that she was on her back with her legs straight down, feet up and hands by her side. She was lying with her head to the north-west. When they returned with Herring, she was exactly in the same position. Herring confirmed this. He saw that the body was quite cold and stiff, had bled from the nose, and that her tongue, which protruded about an inch, was quite black. He was sure there had been no struggle and had searched the beach for several hundred yards finding nothing. There were no signs of any vehicle or cart.

The inquest was adjourned for a week and then again until 31 July. Before that, Dora's funeral was held on 19 July, at Caister cemetery. The two mourners were Selina, and a friend, Alice Webster. Apart from the clergyman, the only others present were three ladies, the cemetery superintendent and two local reporters. Four London reporters joined when the coffin was taken out of the chapel to the grave.

The present Town Hall: the court room here was the scene of many of the cases in this book

At the adjourned inquest, a different picture of Dora emerged — a lively and flirtatious young lady. Louisa Newman said that she had last seen Dora when she left her work at 9 p.m. on the Saturday. She had stayed away without leave for about a week from June 16, during which time Mrs Newman had seen her on the road a couple of times. When she returned to work on Sat 22 June, Newman asked Dora where she had been and the girl answered 'Norwich'. Newman said she told Dora that she had been seen with different young men on the Drive and on Britannia Pier — 'she admitted she had and said she had done no harm'. Mrs Newman herself had never seen her with any young men. Several letters had come to her at Newman's house, she happened to notice that one had a Fakenham postmark.

New evidence was given by a thirteen-year-old boy, Hubert Baldry, the son of the yacht station attendant. He knew Dora because she often came to the yacht station to ask if a yacht called *Flame*, of Wroxham, belonging to Mr Alfred Collins was there. She continued to come and ask this, but *Flame* arrived only at about midday on the Monday after she was murdered. However, he had seen Dora the previous Sunday at 10.30, when she told him she had been to Lowestoft with a gentleman. She then boarded the *Medea*, a yacht also from Wroxham. She stayed on board until 4.30 p.m. when she got off and the yacht left. She told Baldry that she was going for a walk on the Drive with the gentleman she went to Lowestoft with. On a previous occasion, Baldry had seen her with *five* yachtsmen, all in white sweaters and flannel trousers!

At 10.30 p.m. on 14 April, when, according to Baldry, she had last come to the yacht station, she had been wearing a brown costume. Shown the hat, Baldry said

she was not wearing it at that Sunday meeting, though he had seen her wearing it on other occasions.

Three other, probably more reliable witnesses had also seen Dora on the last night of her life. A bill poster, William Hacon of Row 28, had seen Dora, whom he knew, with a young man at 7.45 p.m. She was wearing a blue costume with a brown straw hat, which he thought was the one now shown in court. The man was dark, six-feet tall, clean-shaven and wearing a light grey suit and dark boots. They were laughing but were not arm in arm. They were going southwards down the Parade.

A pier attendant, John Harris, also saw Dora at about 7.45 p.m., this time at the bottom of Devonshire Road. Harris knew her only as a girl called Dolly, who had come to play box ball on the pier over the last two summers. (This was a game similar to table tennis, but played with the hand rather than a bat.) She called out to him 'Goodnight Mr Box Ball', and he just replied, 'Goodnight'. She was with a man who was between thirty-five and forty, five feet seven or eight [inches], rather fair, clean-shaven, wearing a grey suit, straw hat, walking stick and carrying gloves. He did not think he had seen him with Dora before.

Emily Blyth, who was an assistant at W. H. Rowland's stall on the Marine Parade, knew Dora well. On that Sunday evening, she had seen her going past the stall at about a quarter to nine, just as it was getting dusk. She was with a young man who was about twenty, clean-shaven, of the same height as Dora and wearing a grey suit. Dora said, 'Goodnight', and Emily replied, 'Goodnight Dolly', which was the name by which she knew her. She had seen her once before with a young man, but was not sure if it was the same one.

PC Dix said that when going to the South Denes with the mortuary ambulance to fetch Dora's body, he had picked up a pair of ladies kid gloves lying on the east side of the parade just opposite the road leading to the Monument and 280 yards from where the body was found. They had since been identified as Dora's. Selina said she had not known that Dora had skipped work for a week, as she had continued to come home every night that week just as usual.

The medical evidence was that she had died from being strangled; there was nothing to suggest she had been drugged or chloroformed first. There were marks or abrasions on her chin, suggesting she had struggled. She was still a virgin. The coroner referred to the case as 'a dark mystery, which I am afraid neither you nor I can unravel'. However, from the point of view of the inquest the verdict was clear enough. The jury were out for less than five minutes before saying that the verdict was 'murder by person or persons unknown'.

Dora's murderer was never caught. Was he the same man who had killed Mary Bennett twelve years earlier? The writer Paul Capon thought that he was, suggesting he might have been a sailor who Mary Bennett had met on her trip

to South Africa, and who was also one of the yachtsmen who had fascinated Dora. However, professional seamen are rather different people than fashionable yachtsmen of the kind that Dora was seen with, and twelve years is a very long gap for a serial killer's crimes. It seems likely that Dora suffered the same fate as Mary, murder by a man when she was trying to resist his sexual advances on the beach. The bootlace in the second case was probably inspired by the first one, suggesting a 'copy cat' murder rather than a serial killer.

CHAPTER 18

The Case of the Yarmouth Palm Readers

'To have one's fortune told', Anthony Powell tells us in his book *The Acceptance World*, 'gratifies most of the superficial demands of egotism. There is no mystery about the eternal popularity of divination.' But is it a serious art or just a form of entertainment? These were the issues raised when eight palmists who practised in booths and kiosks along the sea front appeared in Yarmouth police court on 18 August 1909, to be tried under the Vagrancy Act. The Town Clerk, Arnold Miller, said that palmistry was defined in Ogilvie's Dictionary as 'the pretended art of telling fortunes by lines on the palms of the hand, a trick of the hand.' He said that palmistry and fortune telling were two very different things: palmistry 'was subtle craft to impose with attempt to deceive. Fortune telling was prophesying the future; palmistry was reading the hand with intent to deceive.'

The key witnesses in every case were Christopher Vale, a special constable, and Florence Chase, who was the daughter of a police constable. There were no women in the police force in those days, so relatives had to be called on when a female was needed. The pair had gone to each palm reader posing as a visiting couple, and their evidence was the basis of the prosecution cases.

The first case was that of 'Madame Alexander'. Vale said that on 31 July he was in the Sea View Exhibition on the Parade with Miss Chase. He saw a room occupied by Madame Alexander and went in. A man asked him if he wanted to see Madame Alexander, he replied that he did, and the lady herself came in. He asked her, 'Is this the palmistry place?', and she said that it was. He asked the cost and she told him that, 'You buy a book from me for a shilling and I read your hands free.' He said that would have his hands read for 1s. No book was given. Instead Madame Alexander looked at Miss Chase's hands. She let go of her right hand, but 'read' her left one with the aid of a magnifying glass. Vale wrote down what she had said five minutes after he left. As he recalled, Madame Alexander told Miss Chase, 'Jupiter and Mars are not good at present, but as time goes on

107

Uncle Tom's cabin, a pub built into Britannia Pier

will be better. You are going to receive a letter, which will cause you a journey across the sea. You are going to be married, and be the mother of a small family. You are going to see a very great female friend shortly, who will tell you good news for the best. You have a female enemy and, as time goes on, you will be able to deny all she has said about you. You will receive a letter containing news of money left to you.'

Madame Alexander then took hold of Vale's hands, telling him, 'Your lifeline is very bright and you will never want; and you will be happy and comfortable. You will have a change and will receive a letter which will cause you to travel abroad, and have money, but be careful or you will be done out of it by an older person. You will gain money by your industrious ways. You have family troubles, and will be married, but the one your family would like you to have you have refused.' The Town Clerk interrupted to ask if Vale had refused any young lady, but he said, 'No'. He finished by saying that she had also told him he would be far happier in his married life. They were both given a book, with a chart of a hand on the front, and both handed over 1s.

Britannia Pier in the early years of the twentieth century, before the building of the ornate pavilion

The defence counsel, Mr Stewart, doubted if Vale could really have remembered all that, and offered to set up a memory test: the mayor said that this would not be necessary. Florence Chase then gave evidence. She admitted that she knew Madame Alexander by sight but denied that she had a grudge against her. In fact, as Stewart pointed out, Madame Alexander had been doing palmistry sessions in Yarmouth for at least five or six years without complaint.

Madame Alexander herself took the stand. Her real name was Barron, and she had been practising palmistry for twenty years, after studying the subject for thirty-five years. Her mother had taught her. She said that, 'She believed in palmistry and read the lines of the hand by the teaching she had received and her experience. Certain lines indicated certain characteristics and she believed that from them she could infer their past and probabilities as to their future.'

When the Town Clerk rose, she thought he was going to ask her to read his hand and she said she was too nervous at being in Court, so the Town Clerk said he would not ask her. She remembered Vale and Chase and insisted that she had showed them the notices in the booth. She went on to say that, 'She expected the people who came to her did so to be amused. Most of them were visitors on their holidays and they laughed and were very pleased. She never attempted to deceive or impose upon anyone. She did not profess to be a prophetess and none of her customers had ever complained of being dissatisfied. She had even seen penny-in-the-slot fortune tellers at railway stations.'

The notices became the key to the cases. They are supposed to have read:

Arnold Miller, the Town Clerk from 1896

Notice to patrons: Characters will be read as delineated on the hand. No profession of ability to tell fortunes is made. Whatever is stated as a probability from the character revealed from the hand is so stated without intention to deceive, and for the purpose of amusement only.

Vale and Chase denied that they had seen these, and another prosecution witness, Detective Boulton, said that he had been to the booth on 13 August and had not seen such a notice displayed. Stewart countered with a witness who *had* seen them. This was Mr Barron, Madame Alexander's husband. He said that were six notices outside and originally four inside, though these had been reduced to one. Stewart claimed that the notice was the key:

It placed the defendant beyond the statute because it was totally inconsistent with any attempt to deceive. It was done simply to amuse, just as it was at almost every charity bazaar in Yarmouth and elsewhere, Was defendant an impostress, or one who to the best of her ability endeavoured to practice her art after training that was as much an art as the deciphering of impressions of finger tips. What would have been though twenty years ago of the offer of any man to identify, without seeing his face, an individual whose finger tip impression was shown him on a piece of glass? It would have been scoffed at and ridiculed; and yet today the police were quite satisfied to make use of it.

The magistrates conferred; they were evenly divided as to whether to convict or to acquit Madame Alexander. As they could not agree, the case against her was dismissed.

The second palm reader before the court was 'Madame Arthur', who had also been visited by the young 'couple'. Vale said that on 3 August he and Miss Chase went to the kiosk on Regent Road where Madame Arthur practised. According to Vale, Madame Arthur told Miss Chase, while looking at her left hand with a magnifying glass: 'You have a very long life and will be very prosperous in business. The best part of your life will be from twenty-five up to thirty-two.' You will become engaged, after a lot of scandal from friends trying to part you, but your hand does not denote marriage, and your head lines show you will suffer from your nerves. You have a friend who will happen with an accident to leg or foot.'

She had, apparently, looked at Vale's left hand and told him, 'You have a good life line, but your heart line is broken by a great deal of trouble, which will end in the best for you. There will be a death shortly, and you have a friend who will have an accident either by riding or driving. You will meet a gentleman who will tell you good news. About October or November you will go abroad.' The Town Clerk interjected, 'Have you any intention of going abroad?' Witness: 'No.' Madame Arthur had allegedly continued: 'You will be very successful abroad. You have a sister that suffers a great deal.' Town Clerk: 'Is that true?' Witness: 'No.'

The palmist had gone on to say that the sister would undergo two operations and that the second one would be successful. Miss Chase corroborated Vale and, cross-examined, said she did not mind going round to trap these people. Again, the question of notices was debated, and again the palmist said in the box that she did not deceive. She had practised for over thirty years. However, she agreed that she did not supply any books. The Mayor asked if there was a line in the hand that indicated a person was going abroad? Defendant: 'Yes.' The Mayor continued:

> Mayor: 'After he goes abroad does that line die out?'
> Defendant: 'No, it still remains.'
> Mayor: 'Then he keeps on going abroad [Laughter].'

The magistrates consulted, found Madame Arthur guilty, and fined her 20s with costs.

The third case, that of 'Madame Lee', was heard on the following day. Stewart again defended. She practised on the beach near Britannia Pier. She too had been visited by Vale and Chase. Madame Lee asked Vale to put 1s into his hand. She

crossed his palm with the edge of the coin, put it into her pocket and told him to wish. Then she said he would have a letter on 16 August containing good news (no such letter had arrived!). He would also meet an old gentleman who would tell him good news. He would be very lucky and prosperous but he had an enemy, who could not do any harm. He would marry, be the father of two children, become a grandfather, and live to a great age. Very similar things were told to Miss Chase, who also handed over 1s.

Stewart seems to have been a livelier cross-examiner on the second day of the trials. He got Vale to agree that he was not married, and had not given it a second thought, but that he would not object when the time came (This provoked much laughter).

Miss Chase said that Madame Lee had also crossed her hand with the 1s and had told her to make a wish for herself. She did so, and Madame Lee began reading her hand. The palmist told Miss Chase that she wished for a certain young man, whom she would marry, and they would have a small family. She would set up in business and prosper well. She had a great female enemy who would try to do her a lot of harm. After the reading, she was given one of the small books. Miss Chase said that she would not like to give 1s for it, though she had not read it, as she believed no one could write about the future. Miss Chase also said that she saw no notices exhibited; had they been there then she would have seen them.

Cross-examined, she said that she was not imposed on because the future was a sealed book. But the defendant had defrauded her of her money, and she felt ill will to her to a certain extent. This was not why she did not see the notices. Stewart became more personal. 'What did you wish?' Stewart asked. Saul (one of the magistrates) intervened, asking, 'Is that not going a little too far?' The witness did not wish to answer, and questioning continued:

Stewart: 'Then I am to assume the defendant correctly diagnosed your mind?'
Witness: 'It was not right.'
Stewart: 'Have you no wish to get married?'
Witness: 'I did not wish it.'

In further cross-examination, she insisted she had not mixed up what Madame Lee said with what Madame Alexander said. Stewart commented, 'Both ladies told you the same thing, so there seems to be something in it after all.'

Police Constable Clissold had been to the booth with Violet Boulton, the sister of Detective Boulton. He said that they had not seen any notices. However, when cross-examined, he failed to describe *any* of the features in the room. Madame Lee told the court that the room was hung with scarlet baize, and the printed

Modern day 'fortune telling'

notice on a white card was hung on the baize opposite the door. As Stewart said in court, 'So much for the observant officer.'

Madame Lee also defended her art. She said she could tell the number of children a person would have by the lines of the hand. If the person did not have the number she prophesised, she agreed it would be misleading. She was *not* a fortune-teller. She did not tell the future, but read the lines of the hand. There was more than one system of palmistry. She professed the system in the small book. If a cross was found in the region of the middle finger in the 'hypatica' it meant sudden death. She declined to answer when asked if it would be foretelling the future to tell such a client of his death.

The Town Clerk had obviously been reading up and now tried to show that he knew more about the subject than Madame Lee did:

Town Clerk: 'Will you give me another name for the Girdle of Venus?'
Witness: 'I decline to answer.'
Town Clerk: 'If the Girdle of Venus, or singulum veneris, has a sister, what does it argue? [Laughter]'

Madame Lee indignantly declined to answer any such questions. However, when Stewart asked her straightforward questions about lines in the palm, she gave ready answers. He suggested that she should look at a certain line in his hand. Saul intervened to say that his hand should be looked at instead:

Witness: 'Perhaps I should tell him he was fond of ladies, and what would he say to that? [Laughter]'
Saul: 'It would not be very far wrong [Laughter]'
Stewart: 'That makes innocent amusement.'

He had made his point. To prove the power of palm reading, Madame Lee said that her own cousin had read in the hand of the late Duke of Clarence that he would not wear wedding clothes — and he never did. A local printer said that he had printed a dozen notices for Madame Lee. Mrs Clara Stewart, who ran a handkerchief embroidery stall next to Madame Lee's kiosk, said she had seen them on display. After a hearing lasting over four hours, the magistrates acquitted Madame Lee.

Stewart said he could prove there were notices in all the other cases except that of Ormond Stead. The case was adjourned, and on 20 August, the bench announced it was going to go to the High Court to sort out the dispute, so all the remaining cases were postponed indefinitely except that of the notice-less Stead. This 'palmist' was a man. His establishment had been near the Hippodrome, and

the same couple had visited it and paid over their money. Stead had told Miss Chase: 'The first signs of your life have not been very good but as time goes on you will sail on a calm ocean. You are very lovable, and like to be loved, and you don't like it if you are not.' That was all she got for her 1s. He then turned to Vale and, according to the special constable, he was far more specific, saying, 'Your future is very good. You will attain a high position when you reach the age of twenty-seven. You are going to be married and will be kind to women. You will be very careful with your money and not spend it when you cannot afford it. You will not expect too much from your wife but help her as much as possible.' Then, turning back to Miss Chase, he said, 'If this is your intended you have no need to worry.'

Stewart said this whole statement was made up by Vale — and he thought he could prove it. While cross-examining Miss Chase, he learned that she had a copy in her pocket of what Stead had said to her; she had written it down the evening before the case. Obviously he suspected it was not the same as the statement that had been given to the court, and he insisted it be produced. The magistrates said that, as she had not used it in court, he could not do this. Stewart then wrote out a formal 'notice to produce'. This document was torn up in court by the Town Clerk who told Miss Chase not to produce the statement. Tempers were clearly becoming frayed.

Stead himself then took the stand. He stressed his scientific qualifications: he had taken degrees in the subject of palmistry, which had studied for sixteen years, along with phrenology, health culture and healing. He had studied the physiology of the hand, and its mentality. He could discern signs of disease from the fingertips, and many physicians used this method. He **never** made definite statements as to what might occur or what had occurred from the hand: he would only say that certain things were probable. He had a Ph D from Colombia University in New York — and a diploma, but this could not be shown to the court as it was in Birmingham.

Stewart claimed that this case was in a different class than the others: Stead really did believe that he could draw inferences from the lines of the hand, and he was therefore practising a lawful profession, which indeed he had carried on in Yarmouth for the previous four years. However, the magistrates reverted to what had allegedly been said to Vale, and, deciding that it was fortune-telling pure and simple, they found Stead guilty. He was fined 20s and costs, the total penalty coming to £3 8s 6d.

It is interesting to compare these cases a century ago with the witchcraft trials of 250 years earlier. In both cases, the town authorities took action to prevent what they saw as gullible people in the town from being deceived by those with supposed special powers. In the witchcraft case, the authorities themselves may

well have believed that the accused really did have supernatural powers, and the results were fatal for those convicted. In the palmistry case, however, the magistrates were sure that the whole thing was fraudulent, and the results, fines and bans, were much less severe.

CHAPTER 19

The Murder of Police Constable Charles Alger

The police force in Yarmouth, as elsewhere, often have to put themselves in situations of the greatest danger. For one member of the force this led to his death. The *Eastern Daily Press* on Thursday 19 August 1909 had a dramatic 'Stop Press' story to tell:

Gorleston was yesterday afternoon the scene of a sensational tragedy, a constable named Charles Alger being shot and killed, while another man named George Warner and two women who pluckily went to the man's assistance were dangerously wounded. The alleged assailant is a man named Thomas Allen, living on the outskirts of Gorleston, whose occupation is that of a vermin destroyer. He had, it is stated, been warned off certain land by Warner, who is an attendant at Gorleston Recreation Ground, and after a dispute with his wife yesterday afternoon Allen is alleged to have shot Alger, who had come to make enquiries, the charge taking affect in the throat and in the side of the face. The policeman ran a few yards and then dropped, death ensuing soon after. Warner next came up and was shot, and two women who had come to the rescue were also shot. Allen was later overpowered and arrested. Warner is lying in Hospital in critical condition.

The same paper had a fuller report, beginning: 'The summer calm of Gorleston was thrillingly broken yesterday by the murder of a policeman in broad daylight and the wounding of another man and two women before the man responsible for this terrible quarter of an hour's work was arrested and lodged in safe custody.' Alger was about forty years old, with five children. He had been in the force for fourteen years. Allen was about fifty-five, 'of slight build and small stature, with a scrubby beard and bald on the crown of his head'. Although a vermin catcher by profession, he had not worked for some time. He was married and the father of eleven children. He had been before the courts several times, including once for a previous assault upon Alger.

PC Alger – the murder scene

The crime had taken place at about 4 p.m., close to Allen's house, 12 Andrew's Road, which adjoins Gorleston Recreation Ground. The police received a message that Allen was beating his wife and Alger was sent to investigate. When he arrived he asked Allen what the trouble was, and Allen said, 'Come into the garden and I will tell you all about it'. Both men went into the garden, around which people had already begun to gather. Allen pulled out a gun and fired at Alger at point blank range: horribly disfigured, he ran into the street before he collapsed. Warner heard the shot and came into the garden via a gate from the Recreation Ground. With him were two neighbours, Agnes Popay and Muriel Lancaster. Allen fired at Warner, the charge entering his head and neck, while Mrs Popay was wounded in the leg and Miss Lancaster in the hand. The police then arrived, and Allen retreated into his house, but, on being challenged by Inspector Moore, he gave himself up. He was taken to the police station while a cart was found to take Alger and Warner to Gorleston Cottage Hospital. On arrival, Alger was pronounced dead. After being searched, Allen was taken in a cab to Yarmouth gaol.

THE POLICE COURT, INQUEST AND FUNERAL

The police court trial took place on 19 August and was reported in the *Eastern Daily Press* of 20 August, first setting the scene:

> More than half an hour before the Yarmouth Police court opened yesterday, a crowd had gathered around its principal entrance outside the Town Hall in Middlegate Street to catch a glimpse of the accused man, Allen. The police station is only a few yards from the Town Hall, and Allen had been earlier conducted across the roadway, entering the Town Hall by a side door generally used for prisoners, whence a stone staircase conducts direct into the dock in the court above. The public gallery would not accommodate a hundredth part of those seeking admission, and was filled long before the officials of the court arrived to begin the day's grim business. The standing space at the back of the dock was also occupied. Several women were among the spectators in the gallery.
>
> Promptly at eleven o'clock, Allen was brought in by Police-constables Chase and Chamberlin and placed between them in the dock. Prisoner looked somewhat dishevelled, pale and worn but he took his seat as directed, making no sign that he realised his position. As the magistrates headed by the mayor filed in, Allen turned round to see who were seated behind and then looked straight ahead. The Chief Constable came in shortly after bringing prisoner's weapon and the live and cast cartridges found upon him.

The first witness was Alice Cox who lived with her husband John at 8 Andrew's Road. She fainted on entering the witness box, and when she had recovered was allowed to give her evidence sitting down. Between 4.15 and 4.30 p.m. she heard a scream and a cry of 'Murder! Help!' She recognised the voice as that of Mrs Allen, and ran out of her back door to help. She saw Allen strike his wife with 'a rusty piece of a gun' and grabbed him. Mrs Allen ran in to 1 Andrew's Road where a Mrs Gray lived, Allen breaking himself free to chase after her: however, by the time he reached the house the door had been locked and bolted. Alice grabbed Allen once more and begged him to give up the weapon, but he would not. Shaking himself free once more, he went back into his house. She was sure that the gun he had was *not* the one produced in court as the murder weapon, as the one she had seen was much more rusty. In a few moments, she saw him run into his shed and come out with something, which he took into his own house. Deciding that he 'looked mischievous' she went to the police station in the High Street and reported the matter to Inspector Moore. She and Alger came back together and she went back into her house. Ten minutes later she heard the sound of a shot. Going into her back garden she saw Allen and Alger in Allen's garden.

Alger was stooping. She saw Allen reload and run towards the Recreation Garden as Alger staggered and fell. He got on his feet for a moment and fell. Allen had returned and he shot Alger on the ground, and then shot at another man who was approaching.

The mayor told Allen he could ask questions of the witness. Allen asked him to speak up as he was rather hard of hearing, and Inspector Moore shouted out what the mayor had said. Allen said, 'I wish to have this case decided by the planets, and we will see who is right or wrong.'

The second witness was Clara Woodhams of London who was staying with her master and mistress at 24 Andrew's Road. She was in the front room dusting the furniture and went to the front door to give the duster a shake. She saw Allen and Alger near a potato heap in Allen's garden. Allen stooped down and picked up something from under the heap. He almost touched Alger with it and there was a loud report. The constable staggered towards the fence and fell, and she could see that he was covered in blood. She identified the weapon as the gun produced in court. Warner and Mrs Popay went to help Alger. Allen shot at Warner, and parts of the shot also struck the two women. Warner was taken away to Hospital and a cart was found for Alger's body.

Third witness was Inspector Moore. He described how Allen was arrested and the journey to Yarmouth. Alger's death was announced to the Yarmouth police by telephone. Allen, overhearing, asked 'Is he dead?' When the police told him that he was, his only comment was, 'It's all through her' — a remark heard by both Inspector Moore and Chief Constable Moore.

In the afternoon of the day of the hearing, the inquest was held at Church Road Boys' School. Allen listened quietly, alternately folding his arms and supporting his chin with one hand. The coroner commented on the tragedy of the case, lamenting that Mrs Alger had been left a widow with four children. The jury went to the Cottage Hospital where they viewed Alger's body. They also saw Warner and then went to the scene of the crime. According to the local press, 'The prisoner Allen lived at the end house of the terrace on the south side and abutting on his house is a piece of land which, not being occupied yet for building, he was permitted to cultivate, and here he grew potatoes. It was in this potato patch that the tragedy was enacted. The locality has that quiet aspect which suggests it would be the last place in the world to be stained by tragedy, all the occupants being decent recent respectable folk.'

The body was formally identified by Alger's widow, Rosa Alger, who lived at 36 Trafalgar Road. She said that her husband was thirty-seven years old and had been in good health. Mrs Cox gave the same evidence as she had in the morning, and the jurors were then able to ask her questions. One asked if Allen seemed to be sober or as if he had been drinking and she answered that

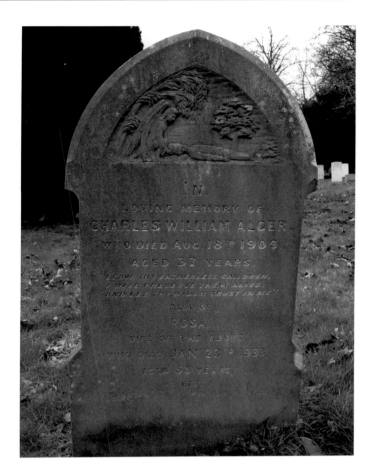

Grave of PC Alger in Gorleston cemetery, with detail showing death of a policeman

he seemed to be 'in drink'. Allen was asked if he wanted to put any questions to her. He replied, 'Not till next Thursday.' The servant also gave her evidence, (this time she is called Sarah not Clara — such mistakes are common in these newspaper reports). Inspector Moore also repeated what he had said in the morning. Questioned by the jurors, he said that he did not think Allen was in the habit of carrying a gun, and that although he was excited, he did not think he was drunk.

The medical evidence followed. Alger had been peppered with shot from point-blank range, severing his artery. He had died of haemorrhage and shock.

One juror asked why Allen's wife was not present, as they could have inquired into his state of mind, and the coroner said that that should be left to the judges (he was obviously assuming that there would be a trial). Another juror pointed out that one witness had said Allen seemed to be drunk. However, the coroner was having none of this, saying firmly, 'Drunkenness is no excuse for crime, but

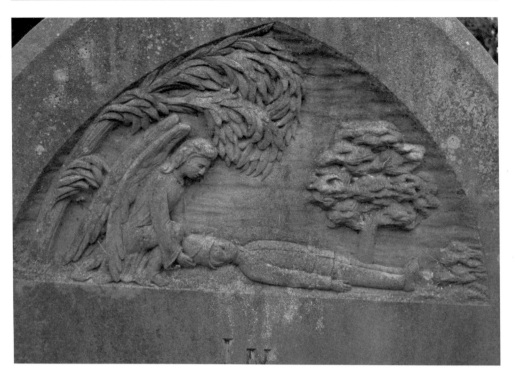

Detail from PC Alger's grave

rather intensifies it.' The jury were out for less than five minutes before returning with their verdict, 'wilful murder against Allen'. That evening, Allen was taken to Norwich Prison to await trial at the Assizes.

Meanwhile, the preliminary session before the magistrates at the town hall had been adjourned until 26 August. Allen was brought from Norwich for the hearing at the town hall; he came by the 9 a.m. train. Warner was still too ill to attend. Mrs Popay, who was the wife of George Popay, fisherman of 26 St Andrew's Road, gave her evidence. Allen had come back to within seven yards of Warner, as she turned away she heard the gun go off and felt a sudden sting in her left leg. She went into her house and found that she was bleeding. She went to the Hospital but was not kept there overnight. The Mayor told Allen he could ask questions of the witnesses if he wanted to, but advised him against doing so as he was not legally represented. Allen said that he had a statement in his pocket that he had written in prison. He produced it but asked no questions. Muriel Lancaster also gave evidence, saying that a small piece of shot from Allen's gun had hit her left hand.

Alger's funeral had already taken place on 23 August. It was a grand procession, beginning outside the Alger's home in Trafalgar Road and going

through the High Street to Gorleston church. Alger's police comrades headed the procession, followed by the hearse, the family mourners and almost every official body in the town: the town officials, men from the Royal Garrison artillery, tramways staff, coastguards, customs house staff, postmen and many others. Six of Alger's fellow policemen acted as bearers. After the service in the church, the funeral procession continued to the cemetery where Alger was buried in a tract of turf near the chapel that had not previously been used. It was pouring with rain.

The final session before the magistrates took place at Yarmouth Town Hall on 2 September: Warner was well enough to give evidence at last. He had seen Alger lying on the ground and had gone to his aid, loosening his collar. He thought someone or something hit him on the head, and putting his hand to it, found that he was bleeding profusely. Two other men who were present, Charles Hammond, a train driver, and William Bullock a house painter, gave supporting evidence. Allen was committed for trial at the Assizes in Norwich.

THE TRIAL

The trial was held on 28 August 1909. The people who had given evidence at the magistrates' court and the inquest repeated their stories including Mrs Cox, Clara Woodhouse, Agnes Popay, George Warner, the policemen and the medical experts. The defence counsel, Mr Taylor, did not challenge the facts and produced just one witness. This was Doctor Craig of Guy's Hospital, a specialist in mental diseases who had interviewed Allen twice in prison. He said that for the first twenty-five years of their marriage the couple had been happy, but that over the last five years Allen had become obsessively jealous. He was sure that men were kissing their hands to his wife, suspected them when they coughed, and thought that they were making signs and whispering to her. He hid in the coal shed to try to catch her out and bought the gun to avenge himself against these supposed philanderers, not to kill them but to 'sting them up' — that is, wound them. In answer to a question from the judge, Craig said that Allen had never accused Alger of being one of these men. Allen agreed, saying that Alger was not one of these men, and he had just meant to warn the policeman off, but the trigger was unguarded and the gun went off in his hand.

The judge had then to sum up the case. He said that the issue to be decided was whether the delusion or partial insanity from which Allen was suffering accounted for the crime which was committed, 'the question was whether prisoner knew at the time he shot Alger that he would do him grievous bodily harm. Did he know what he was doing was wrong and contrary to law?'

The jury clearly thought he did; they were out for just five minutes before returning with their verdict of 'guilty'. The judge donned his black cap and sentenced Allen to death. He was returned to Norwich to face execution, which was fixed for 16 November. However, just a few days before this date, he was reprieved and sent to Broadmoor for the rest of his life.

References and Acknowledgements

Twenty-two images in this book are from the archives of the Norfolk Record Office: I am grateful to the County Archivist, Dr John Alban, for permission to use these images. The Record Office references are as follows:

Page 8 (upper), NRO, Y/D 71/10
Page 8 (lower), NRO, MC 2641/1
Page 12, NRO, Y/S ½
Pages 16 (upper), 66, NRO, Y/D 50/378
Page 21, NRO, Y/S 3/109
Pages 23, 67, 76, 91, 110, NRO, Y/D 94/39
Page 27, NRO, Y/S 2/4
Page 29, NRO, Y/D 7¼
Pages 33 (lower), 104, NRO, Y/D 36/2
Page 41, NRO, MC 2645/1
Page 63, NRO, Y/S 3/173
Page 82, NRO, MC 2649/1
Pages 87, 101, NRO, Y/D 36/4
Page 92, NRO, MC 2640/1
Page 108, NRO, MC 2651/1

Images on pages 43 and 51 are from Broadsides held at the Norfolk Heritage Centre, Norwich: I am grateful for permission to use these images.

Also available from Amberley Publishing

Yarmouth & Gorleston Through Time
by Frank Meeres

Price: £12.99
ISBN: 978-1-84868-456-0

Available from all good bookshops or from our website
www.amberley-books.com

Also available from Amberley Publishing

Norwich Through Time
by Frank Meeres

Price: £14.99
ISBN: 978-1-84868-458-4

Available from all good bookshops or from our website
www.amberley-books.com

Also available from Amberley Publishing

Norwich Murders & Misdemeanours
by Frank Meeres

Price: £12.99
ISBN: 978-1-84868-457-7

Available from all good bookshops or from our website
www.amberley-books.com